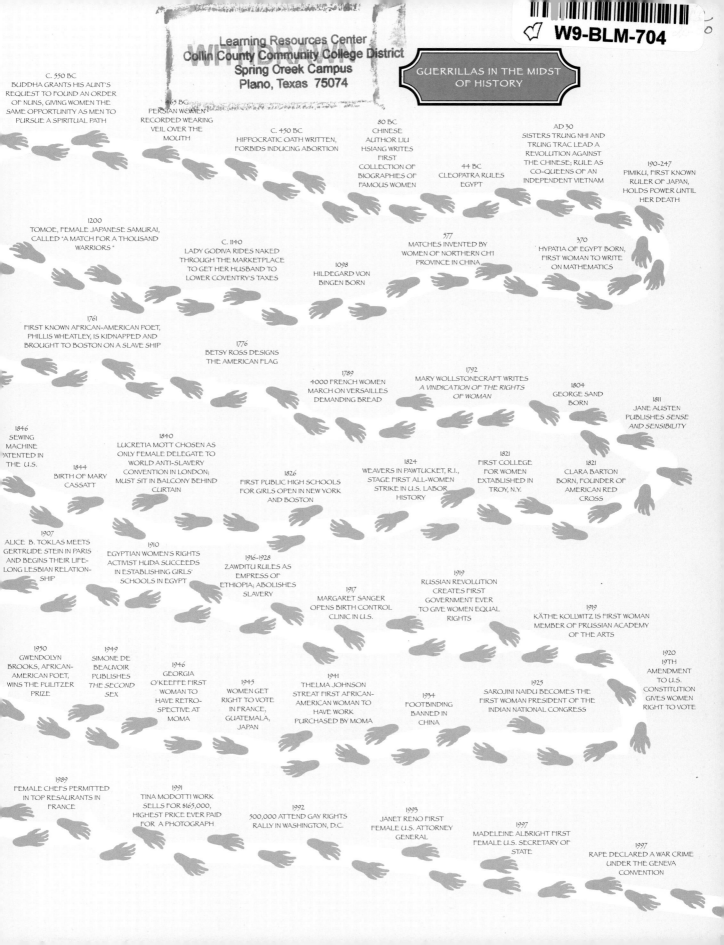

GUERRILLAS IN THE MIDST OF HISTORY

C. 550 BC
BUDDHA GRANTS HIS AUNT'S REQUEST TO FOUND AN ORDER OF NUNS, GIVING WOMEN THE SAME OPPORTUNITY AS MEN TO PURSUE A SPIRITUAL PATH

465 BC
PERSIAN WOMEN FIRST RECORDED WEARING VEIL OVER THE MOUTH

C. 450 BC
HIPPOCRATIC OATH WRITTEN, FORBIDS INDUCING ABORTION

80 BC
CHINESE AUTHOR LIU HSIANG WRITES FIRST COLLECTION OF BIOGRAPHIES OF FAMOUS WOMEN

44 BC
CLEOPATRA RULES EGYPT

AD 30
SISTERS TRUNG NHI AND TRUNG TRAC LEAD A REVOLUTION AGAINST THE CHINESE; RULE AS CO-QUEENS OF AN INDEPENDENT VIETNAM

190-247
PIMIKU, FIRST KNOWN RULER OF JAPAN, HOLDS POWER UNTIL HER DEATH

1200
TOMOE, FEMALE JAPANESE SAMURAI, CALLED "A MATCH FOR A THOUSAND WARRIORS"

C. 1140
LADY GODIVA RIDES NAKED THROUGH THE MARKETPLACE TO GET HER HUSBAND TO LOWER COVENTRY'S TAXES

1098
HILDEGARD VON BINGEN BORN

577
MATCHES INVENTED BY WOMEN OF NORTHERN CH'I PROVINCE IN CHINA

370
HYPATIA OF EGYPT BORN, FIRST WOMAN TO WRITE ON MATHEMATICS

1761
FIRST KNOWN AFRICAN-AMERICAN POET, PHILLIS WHEATLEY, IS KIDNAPPED AND BROUGHT TO BOSTON ON A SLAVE SHIP

1776
BETSY ROSS DESIGNS THE AMERICAN FLAG

1789
4000 FRENCH WOMEN MARCH ON VERSAILLES DEMANDING BREAD

1792
MARY WOLLSTONECRAFT WRITES *A VINDICATION OF THE RIGHTS OF WOMAN*

1804
GEORGE SAND BORN

1811
JANE AUSTEN PUBLISHES *SENSE AND SENSIBILITY*

1846
SEWING MACHINE PATENTED IN THE U.S.

1840
LUCRETIA MOTT CHOSEN AS ONLY FEMALE DELEGATE TO WORLD ANTI-SLAVERY CONVENTION IN LONDON; MUST SIT IN BALCONY BEHIND CURTAIN

1844
BIRTH OF MARY CASSATT

1826
FIRST PUBLIC HIGH SCHOOLS FOR GIRLS OPEN IN NEW YORK AND BOSTON

1824
WEAVERS IN PAWTUCKET, R.I., STAGE FIRST ALL-WOMEN STRIKE IN U.S. LABOR HISTORY

1821
FIRST COLLEGE FOR WOMEN ESTABLISHED IN TROY, N.Y.

1821
CLARA BARTON BORN, FOUNDER OF AMERICAN RED CROSS

1907
ALICE B. TOKLAS MEETS GERTRUDE STEIN IN PARIS AND BEGINS THEIR LIFE-LONG LESBIAN RELATIONSHIP

1910
EGYPTIAN WOMEN'S RIGHTS ACTIVIST HUDA SUCCEEDS IN ESTABLISHING GIRLS' SCHOOLS IN EGYPT

1916-1928
ZAWDITU RULES AS EMPRESS OF ETHIOPIA; ABOLISHES SLAVERY

1917
MARGARET SANGER OPENS BIRTH CONTROL CLINIC IN U.S.

1919
RUSSIAN REVOLUTION CREATES FIRST GOVERNMENT EVER TO GIVE WOMEN EQUAL RIGHTS

1919
KÄTHE KOLLWITZ IS FIRST WOMAN MEMBER OF PRUSSIAN ACADEMY OF THE ARTS

1950
GWENDOLYN BROOKS, AFRICAN-AMERICAN POET, WINS THE PULITZER PRIZE

1949
SIMONE DE BEAUVOIR PUBLISHES *THE SECOND SEX*

1946
GEORGIA O'KEEFFE FIRST WOMAN TO HAVE RETROSPECTIVE AT MOMA

1945
WOMEN GET RIGHT TO VOTE IN FRANCE, GUATEMALA, JAPAN

1941
THELMA JOHNSON STREAT FIRST AFRICAN-AMERICAN WOMAN TO HAVE WORK PURCHASED BY MOMA

1934
FOOTBINDING BANNED IN CHINA

1925
SAROJINI NAIDU BECOMES THE FIRST WOMAN PRESIDENT OF THE INDIAN NATIONAL CONGRESS

1920
19TH AMENDMENT TO U.S. CONSTITUTION GIVES WOMEN RIGHT TO VOTE

1989
FEMALE CHEFS PERMITTED IN TOP RESAURANTS IN FRANCE

1991
TINA MODOTTI WORK SELLS FOR $165,000, HIGHEST PRICE EVER PAID FOR A PHOTOGRAPH

1992
500,000 ATTEND GAY RIGHTS RALLY IN WASHINGTON, D.C.

1993
JANET RENO FIRST FEMALE U.S. ATTORNEY GENERAL

1997
MADELEINE ALBRIGHT FIRST FEMALE U.S. SECRETARY OF STATE

1997
RAPE DECLARED A WAR CRIME UNDER THE GENEVA CONVENTION

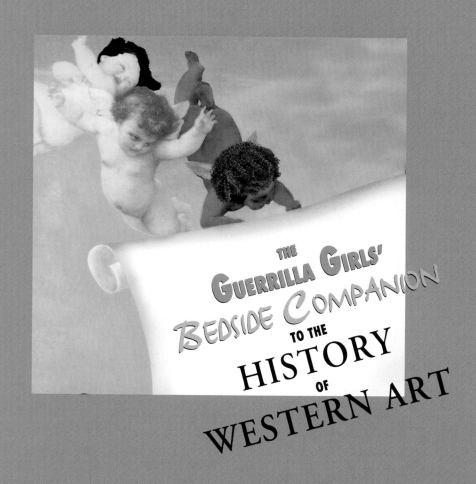

THE Guerrilla Girls' Bedside Companion TO THE HISTORY OF WESTERN ART

BY THE GUERRILLA GIRLS

PENGUIN BOOKS
Published by the Penguin Group
Penguin Books USA Inc., 375 Hudson Street, New York, New York 10014, U.S.A.
Penguin Books Ltd, 27 Wrights Lane, London W8 5TZ, England
Penguin Books Australia Ltd, Ringwood, Victoria, Australia
Penguin Books Canada Ltd, 10 Alcorn Avenue, Toronto, Ontario, Canada M4V 3B2
Penguin Books (N.Z.) Ltd, 182–190 Wairau Road, Auckland 10, New Zealand

Penguin Books Ltd, Registered Offices:
Harmondsworth, Middlesex, England

First published in Penguin Books 1998

11 12 13 14 15 16 17 18 19 20

Previous book by the authors: *Confessions of the Guerrilla Girls*

LIBRARY OF CONGRESS CATALOGING IN PUBLICATION DATA
The Guerrilla Girls' bedside companion to the history of western art/
 the Guerrilla Girls
 p. cm.
 ISBN 0 14 02.5997 X
 1. Women artists. 2. Feminism and art. 3. Art–History.
 I. Guerrilla Girls (Group of artists)
 N8354.G84 1998
 704'.042–dc21 97-31145

Printed in the United States of America
Designed by the Guerrilla Girls

CONTENTS

Forget the stale, male, pale, Yale textbooks, this is Art Herstory 101!

If you were to believe what many of us were taught in school and museums, you would think a clear line of achievement links one genius innovator to the next. For example, Michelangelo paves the way for Caravaggio. Or, a few hundred years later, Monet begets Cézanne, who influences Picasso, who brings us to Pollock. This is the canon that–until recently–most of us took for granted as the history of Western art. It reduced centuries of artistic output to a bunch of white male masterpieces and movements, a world of "seminal" and "potent" art where the few women you hear about are white, and even they are rarely mentioned and never accorded a status anywhere near the big boys. Now, the Guerrilla Girls admire the old "masters"–and lots of young ones, too. But we also believe–along with most contemporary scholars–that the time has come, once and for all, for the canon to be fired.

The famous query by feminist artists and art historians goes, "Why haven't there been more great women artists throughout Western history?" The Guerrilla Girls want to restate the question: "Why haven't more women been *considered* great artists throughout Western history?" And we have a lot more questions (see below), because even though making it as an artist isn't easy for *anyone,* the history of art has been a history of discrimination.

Look at the attitudes toward women emanating from some of the most celebrated male minds of Western culture (quotations, above). Notice how little these attitudes

Why do we always have to be called "women artists"? They don't call Rembrandt and Van Gogh "male artists."

GEORGIA O'KEEFFE

Why does being African-American and female make it twice as hard for my work to be remembered?

EDMONIA LEWIS

changed from the 6th century B.C. to the 19th century A.D. (Remember, women didn't even get the vote in the U.S. until 1919, in France until 1945.) With misogyny and racism the ideologies of the day, backed up with repressive laws, it is amazing that any women became artists at all, especially when you realize that until this century, women were rarely allowed to attend art schools, join artists' guilds or academies, or own an atelier. Many were kept from learning to read or write. For most of history, women have, by law, been considered the property of their fathers, husbands, or brothers, who almost always believed women were put on earth to serve them and bear children.

The truth is that, despite prejudice, there have been lots of women artists throughout Western history. From ancient Greece and Rome there are accounts of women painters who earned more than their male counterparts. In the Middle Ages, nuns made tapestries and illuminated manuscripts. In the Renaissance, daughters were trained to help in their fathers' ateliers; some went on to have careers of their own. In the 17th and 18th centuries, women excelled at portraiture and broke new ground in the scientific observation of plants and animals. In the 19th century, women cross-dressed for success or lived in exile, far enough from home to behave as they pleased. In the 20th century, the ranks of white women artists and women artists of color swelled. These artists were part of every 20th-century "ism" and started a few of their own, too.

But even after overcoming incredible obstacles, women artists were usually ignored by critics and art historians–who claimed that art by white women and people of color didn't meet their "impartial" criteria for "quality." These impartial standards place a high value on art that expresses white male experience and a low

A WOMAN BY ANY OTHER NAME...

For years the Guerrilla Girls have been using the label "women and artists of color" to describe the "others" we represent. But we've always felt the phrase was inadequate because it's unclear where women of color fit in: they are BOTH women AND artists of color. Furthermore, the history of Western art is primarily a history of white Europeans in which people of color have been excluded and marginalized. So, while we declare that when we use the word "women" we mean ALL women, we wish there was a better term to express the diverse experiences of Asians, blacks, Latinas, Native Americans, etc.

Why is The Museum of Modern Art more interested in African art than in art by African-Americans?

Why did so few male art historians mention me in their survey books?

ALMA THOMAS

ARTEMISIA GENTILESCHI

value on everything else. Twentieth-century art historians have worse records vis-à-vis women than their earlier counterparts: Pliny the Elder in the 1st century A.D., Boccaccio in the 14th, and Vasari in the 16th acknowledged more women artists than Meyer Schapiro, T.J. Clark and H.W. Janson in the 20th.

Luckily, in recent decades feminist art historians, most of whom are–surprise!–women, have resurrected and revalued hundreds of women artists from the past. Whenever an art history survey, like Janson's *History of Art* or Gardner's *Art Through the Ages* adds a female author, the number of women artists included–white and of color–miraculously increases. The Guerrilla Girls have gratefully benefited from the ideas and research of these scholars, several of whom have secretly helped us write this book.

THE ADVANTAGES OF BEING A WOMAN ARTIST:

Working without the pressure of success.
Not having to be in shows with men.
Having an escape from the art world in your 4 free-lance jobs.
Knowing your career might pick up after you're eighty.
Being reassured that whatever kind of art you make it will be labeled feminine.
Not being stuck in a tenured teaching position.
Seeing your ideas live on in the work of others.
Having the opportunity to choose between career and motherhood.
Not having to choke on those big cigars or paint in Italian suits.
Having more time to work when your mate dumps you for someone younger.
Being included in revised versions of art history.
Not having to undergo the embarrassment of being called a genius.
Getting your picture in the art magazines wearing a gorilla suit.

A PUBLIC SERVICE MESSAGE FROM **GUERRILLA GIRLS** CONSCIENCE OF THE ART WORLD
532 LaGUARDIA PLACE, #237 • NY, NY 10012
fEmail: guerrillagirls@voyagerco.com

POSTER BY THE GUERRILLA GIRLS, 1986

The Guerrilla Girls' Bedside Companion to the History of Western Art isn't a comprehensive survey of women artists in history. It doesn't include all the cultures of the world. It's not a list of the most significant women artists. It wasn't written for experts who already know all this stuff. Writing about women artists in Western history is complicated. There are lots of contradictory positions and theories. We have opted to stay out of the theory wars, and present our irreverent take on what life was like for some females in the West who managed, against all odds, to make art. It's ammunition for all the women who are–or will become–artists.

OFFICIAL DISCLAIMER: A GRAVE APPROACH TO ART HISTORY

WE'VE RESTRICTED THE BOOK TO DEAD ARTISTS BECAUSE WE DON'T BELIEVE IN EVALUATING OR EXCLUDING OUR PEERS. EVEN SO, IT'S BEEN HARD TO DECIDE WHOM TO WRITE ABOUT. THERE ARE MANY WOMEN ARTISTS WHO DESERVE TO BE IN THIS BOOK AND WOULD BE IF WE HAD MORE ROOM.

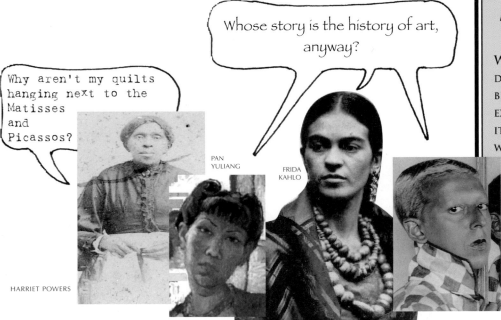

Whose story is the history of art, anyway?

Why aren't my quilts hanging next to the Matisses and Picassos?

PAN YULIANG

FRIDA KAHLO

CLAUDE CAHUN

HARRIET POWERS

9

CHAPTER 1: CLASSI BABES

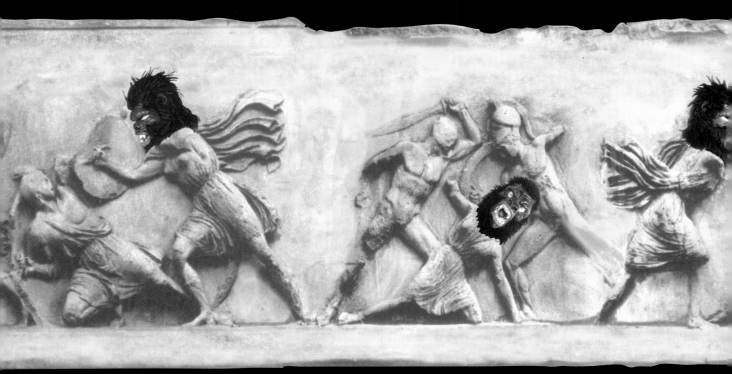

THE BATTLE OF THE SEXES:

AMAZON GUERRILLAS FIGHT THE GREEKS, 4TH CENTURY B.C. FRIEZE FROM THE MAUSOLEUM OF HALICARNASSUS, BUDRON, TURKEY.
AMAZONS WERE BIG, TOUGH, MYTHOLOGICAL WOMEN WARRIORS. THEY LIVED WITHOUT MEN AND RAIDED COED SETTLEMENTS,
RAPING WHEN THEY NEEDED TO PROCREATE. THEY KEPT THE FEMALE BABIES AND KILLED THE MALES. THEY CUT OFF ONE BREAST TO BE
BETTER ARCHERS. IT USED TO BE THOUGHT THAT AMAZONS WERE FANTASIES, THE MYTHOLOGICAL EMBODIMENT OF MALE FEARS.
NEW ANTHROPOLOGICAL EVIDENCE SUGGESTS THAT FEMALE-DOMINATED SOCIETIES LIKE THE AMAZONS PROBABLY DID EXIST.

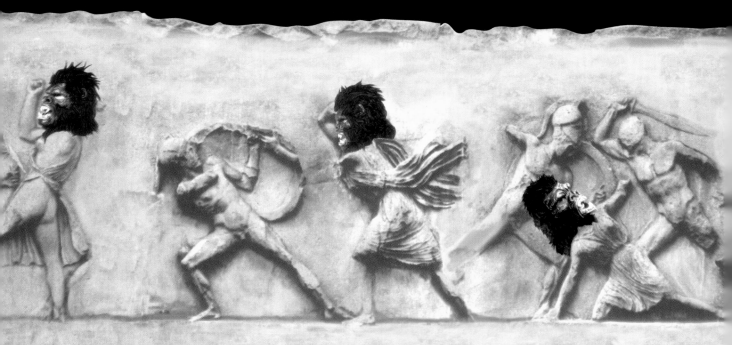

IT IS ABSURD TO ARGUE FROM AN ANALOGY WITH WILD ANIMALS AND SAY THAT MEN AND WOMEN OUGHT TO ENGAGE IN THE SAME OCCUPATIONS, FOR ANIMALS DO NOT DO HOUSEWORK.
—ARISTOTLE, POLITICS, (4TH CENTURY B.C.)

[THE FAMILY CONSISTS OF RULER AND RULED, AND] AS REGARDS MALE AND FEMALE, THIS RELATIONSHIP OF SUPERIOR AND INFERIOR IS PERMANENT.
—ARISTOTLE, QUOTED IN GREECE AND THE HELLENISTIC WORLD

MEN PRODUCE FEMALE AS WELL AS MALE SEED. SO DO WOMEN. MALE SEED IS STRONGER THAN FEMALE SEED...IF THE STRONGER SEED COMES FROM BOTH SIDES, IT PRODUCES A MALE; IF THE WEAKER, IT PRODUCES A FEMALE.
—HIPPOCRATES, ON GENERATION, C. 400 B.C.

Oh! to have lived in ancient Greece or Rome, cradle of civilization, land of toga parties, birthplace of Western philosophy, science, and art. Oh! to have been a part of it all...well, unless you were female. For the classical world so many of us have admired was also classic in its attitude toward women, who could not participate in the famous Greek "democracy" and were rarely even allowed to leave their homes.

Western Europe has always been in love with ancient Greece and Rome. Classical texts and languages have been at the heart of European education and knowledge for centuries. (During the Renaissance, "classicism" was considered the essence of "modernity.") Histories of Western art have often begun with Greece and Rome, establishing the idea that their art was the progenitor of all later art. The Western canon, the set of rules against which all must measure up, begins with classicism.

Although each Greek city-state differed a bit, ancient Greece was a rigidly stratified society, consisting of citizens, freemen, dependents, and slaves. Only men could be citizens; only citizens could vote or own estates, property, or livestock. You were stuck in the class you were born into and could move to another only by a vote of the citizens. Women of all classes were considered inferior. Even the wives of citizens were not important enough to be counted in censuses in most of the ancient world until the 3rd century A.D. Power rested with a small group of privileged males (about 13 percent of the population) who occupied themselves managing property and slaves, engaging in politics, and waging war.

Despite our veneration of classical art as the embodiment of classical values, art and artists were not very important in the Greek social structure. Art, because of the physical labor involved, wasn't considered an intellectual activity. The most famous Greek writers did not accord visual artists anywhere near the status given to musicians and poets. Still, it was forbidden for any slave–male or female–to be taught to paint.

DO'S AND DON'TS FOR WOMEN IN ANCIENT GREECE AND ROME

Think of women in the classical world. Strong and fierce personalities come to mind, like Medea, Clytemnestra, Antigone, Athena, Hera, and Artemis. But take a reality check: these are fictional characters, from drama and myth. According to Greco-Roman custom and law, the facts of life for real women were these:

·WOMEN COULD NOT VOTE OR ENGAGE IN TRANSACTIONS WORTH MORE THAN A GRAIN OF BARLEY.

·IN ATHENS, A WIDOW COULD INHERIT HER HUSBAND'S PROPERTY ONLY IF SHE IMMEDIATELY MARRIED ONE OF HIS CLOSE MALE RELATIVES AND CEDED IT ALL TO HIM.

·IN SPARTA, WOMEN COULD INHERIT PROPERTY UNTIL THE 3RD CENTURY B.C., WHEN 2/5 OF ALL LAND BELONGED TO THEM. THEN MEN CHANGED THE LAW.

·A GREEK WOMAN WHO GAVE BIRTH AFTER A DIVORCE WAS COMPELLED BY LAW TO OFFER THE CHILD TO HER FORMER HUSBAND.

·WOMEN FROM THE LOWER CLASSES IN GREECE COULD BE SOLD BY THEIR FATHERS AS CONCUBINES. WHEN THEY AGED AND THEIR MASTER NO LONGER WANTED THEM, THEY BECAME SERVANTS TO THE FAMILY.

·A MAN COULD DIVORCE HIS WIFE IF SHE WAS UNFAITHFUL, PRACTICED SORCERY, OR WAS A PROSTITUTE, OR IF HE WANTED TO MARRY AN HEIRESS. A WOMAN COULD DIVORCE HER HUSBAND ONLY IF HE COMMITED MURDER, NECROPHILIA, OR ANOTHER REALLY BAD CRIME.

·IN ROME, WOMEN OF THE CITIZEN CLASS GAINED A FEW RIGHTS. THEY WERE ALLOWED TO GO OUT IN PUBLIC AND ATTEND DINNER PARTIES, PAGEANTS, PLAYS AND OTHER SOCIAL EVENTS. SOME OF THEM LEARNED TO READ AND WRITE.

Things were looser in Rome, a vast empire with more centralized laws. There were still strict classes of patricians, plebeians, freemen, and slaves, but wealth was more spread out among them. In Rome, unlike in most of the Greek city-states, some women were allowed to be educated. Women of the lower classes had a bit more freedom of movement than those of the upper class. Ironically, courtesans and mistresses were permitted to participate with men in public activities forbidden to wives.

But relax, the classical world wasn't all that bad: it was misogynist but not homophobic. That is, if you were a man. Love between older mentors and young males was considered the highest form of friendship in Greece. Roman emperors built entire villas for their young male lovers. But homosexuality between women, if one of them was married, was considered adultery, a punishable crime. Somehow, the Greek poet Sappho, a priestess living on her own island, escaped this censure and wrote eloquently of her love for other women.

One of the biggest problems in identifying art made by women in the ancient world is that not much art from the period has survived. Wars, purges, acts of early Christian censorship, and two thousand years of decay have destroyed most of the originals. There are no existing examples of Greek painting, and most of what we know about Greek sculpture is from copies made by Romans or second- and third-hand descriptions by Greek and Roman writers who never saw the original works. Classical art is a bit like classical mythology: stories about it have been told and retold from generation to generation, changing a bit each time, until no one can be sure what really happened when and what works are authentic.

ART HISTORY IS THREADBARE

FROM TIME IMMEMORIAL IN THE WEST, THE PRODUCTION OF TEXTILES HAS BEEN PRETTY MUCH THE DOMAIN OF WOMEN. ANCIENT GREECE AND ROME WERE NO EXCEPTION. WOMEN OF ALL CLASSES PARTICIPATED IN DESIGNING, WEAVING, AND STITCHING DOMESTIC AND CEREMONIAL CLOTH. THEIR WORK WAS HIGHLY VALUED, TREASURED, AND EVEN USED AS CURRENCY.

SO WHY DO ART HISTORIANS CARE MORE ABOUT ARCHITECTURAL RUINS, FRAGMENTS OF VASES, SCULPTURES OF NAKED BODIES, AND DESCRIPTIONS OF DESTROYED PAINT-INGS THAN THEY DO ABOUT TAPESTRIES, TUNICS, TOGAS, AND BANNERS? IF MEN HAD DONE THE SEWING, WOULD UNDERWEAR BE HANGING IN THE LOUVRE?

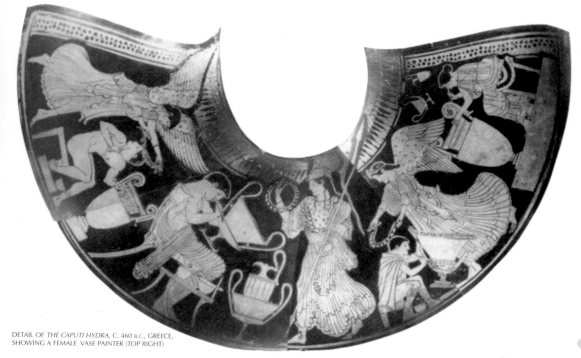

DETAIL OF *THE CAPUTI HYDRA*, C. 460 B.C., GREECE, SHOWING A FEMALE VASE PAINTER (TOP RIGHT)

JOHANNES WINCKELMANN, AN 18TH-CENTURY GERMAN OBSESSED WITH GREEK ART, WROTE SOME OF THE FIRST BOOKS ABOUT IT AND INSPIRED MANY NEOCLASSICAL ARTISTS OF HIS OWN TIME. HE INVENTED GRAND THEORIES ABOUT GREEK IDEALISM, NATURALISM, AND THE SUBLIME. HIS OPINIONS BECAME THE OPINIONS OF OTHER AUTHORITIES, AND INFLUENCED ARCHAEOLOGICAL STUDIES AND MUSEUM ACQUISITIONS FOR CENTURIES. HE WAS A HOMOSEXUAL WHO ADORED ARCHAIC-PERIOD STATUES OF YOUNG, NAKED MALES AND THOUGHT THEY WERE THE HIGHEST EXPRESSION OF PERFECTION. HE WAS INFATUATED WITH THE GREEK CUSTOM OF PLATONIC LOVE, WHICH ENCOURAGED PASSION BETWEEN YOUNG AND OLDER MEN. HE HAD LESS INTEREST IN STATUES OF WOMEN AND DISLIKED THE MORE REALISTIC, WRINKLED, WRITHING FIGURES OF THE LATER HELLENISTIC PERIOD.

WINCKELMANN ON WINCKEL-WOMEN:

"FOR THE SAME REASON THAT I FIND LESS TO NOTICE IN THE BEAUTY OF THE FEMALE SEX, THE STUDY OF THE ARTIST IN THIS DEPARTMENT IS MUCH MORE LIMITED AND EASY; EVEN NATURE APPEARS TO ACT WITH MORE FACILITY IN THE FORMATION OF THE FEMALE THAN OF THE MALE SEX, SINCE THERE ARE FEWER MALE THAN FEMALE CHILDREN BORN."

–WINCKELMANN, *History of Ancient Art Among the Greeks*, LONDON, 1850

GRAVESTONE FOR A YOUNG MAN, ARTIST UNKNOWN, C. 340 B.C., ATHENS

BEAUTY AND THE BEASTS:

WINCKELMANN WROTE PAGES AND PAGES IN A SPECIAL CHAPTER ABOUT MALE BEAUTY, DESCRIBING THE IDEAL HAIRSTYLE AND THE PROPER HANG OF THE TESTICLES. WHEN HE WROTE ABOUT IDEAL BEAUTY IN THE FEMALE SEX, HE INTERSPERSED HIS REQUIREMENTS FOR FEMALES WITH PASSAGES ON THE IDEAL DEPICTION OF HORSES AND OTHER ANIMALS.

There *were* women artists in Greece and Rome, although we will never know how many or even what race they might have been. There are vases and reliefs that depict women painters (see page 13 and below). There are records of women in Rome heading workshops producing sculpture and painting, usually after the deaths of their artist husbands. Pliny the Elder, a 1st-century A.D. Roman chronicler of ancient Greece, mentioned at least six women painters in his *Natural History.* He said that one artist, Iaia of Cyzicus, earned more money for her work than her male contemporaries. (He also felt it important to mention that she never married.)

Another, Olympias, is said to have had a certain artist as her pupil, so she must also have been a teacher. A third, Timarete, is recorded as being the daughter of a male painter, Micon.

There are no known examples of work by any of these women. But, an important 4th-century B.C. Greek wall painting, *Alexander the Great Confronts Darius III at the Battle of Issus,* is now attributed by many scholars to a woman, Helen of Egypt. (On the next page is a later Roman mosaic copy of it.)

As hard as it is to find art by women from ancient times, it's even harder to find art historians who appreciate the women artists. When they do give a woman praise, they speak of her as if she were an aberration of her sex because of her talent.

Witness Giovanni Boccaccio, the 14th-century Italian author of the *Decameron.* He also wrote an illustrated book, *On Famous Women,* in which he described women from history and mythological women as if both were real. He mentions two Greek painters he has read

PAINTER IN HER STUDIO, ARTIST UNKNOWN, TOMB RELIEF, VILLA ALBANI, ROME, 2ND CENTURY

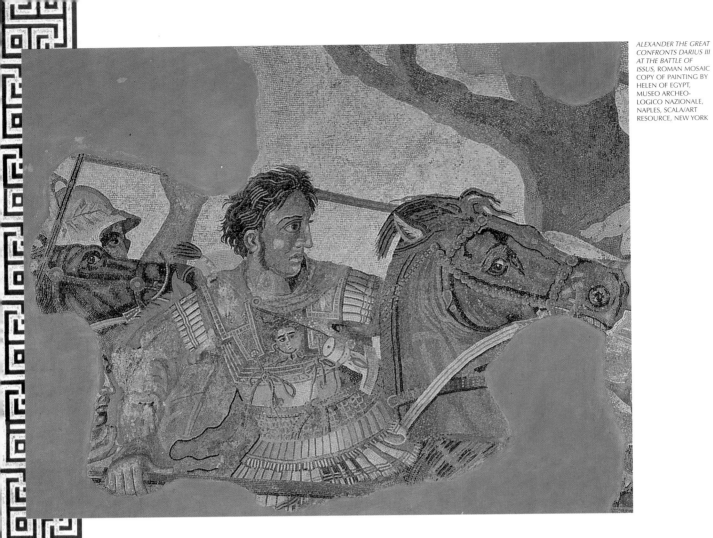

Women's BRAINS *may not be capable of much,*

According to Pliny the Elder (1st century):

·The odor of a woman's burned hair drives away serpents

·The ash of burned hair cures warts, sore eyes, and diaper rash and, mixed with honey, ulcers, wounds, and gout

·Breast milk cures fever and nausea

about in Pliny, Timarete and Irene. Like Pliny, he never saw works by any of them. At right is what he said about Irene. Note how sure he is of his opinion of her and of women in general. Then there was Johannes Winckelmann (see page 14), whose exaltation of male beauty (and lack of interest in female beauty) influenced museums and scholars for centuries.

It's amazing, but Pliny and Boccaccio were more open-minded about including female artists in their histories than John Boardman, a contemporary classicist. Boardman doesn't have a single index entry on women artists in any of his many books on Greek art. Guerrilla Girls can't decide which is worse: to be belittled yet remembered as in days of old; or to be completely ignored by more "enlightened" modern men.

WE DON'T KNOW WHAT HE'S SEEN BUT WE KNOW WHAT HE LIKES:

...[IRENE] WAS THE DAUGHTER OF THE PAINTER CRATINUS. I BELIEVE THAT SHE IS THE MORE WORTHY OF PRAISE, THE MORE SHE SURPASSES HER MASTER IN ART AND FAME....THIS IRENE HAD UNUSUAL TALENT, AND HER SKILL WAS WORTHY OF REMEMBRANCE. I THOUGHT THAT [HER] ACHIEVEMENTS WERE WORTHY OF SOME PRAISE, FOR ART IS VERY MUCH ALIEN TO THE MIND OF WOMEN, AND THESE THINGS CANNOT BE ACCOMPLISHED WITHOUT A GREAT DEAL OF TALENT, WHICH IN WOMEN IS USUALLY VERY SCARCE.

—GIOVANNI BOCCACCIO, ON FAMOUS WOMEN

but watch out for their BODIES.

· The saliva of a fasting woman is "powerful medicine for bloodshot eyes"

· "A woman's breastband tied around the head" relieves headaches

· Menstrual fluid causes new wine to turn sour, seeds in gardens to dry up, steel edges to dull, bronze and iron to rust, dogs to go mad

>
> ...THE HEAD OF EVERY MAN IS CHRIST, AND THE HEAD OF THE WOMAN IS THE MAN....FOR MAN WAS NOT MADE FROM WOMAN, BUT WOMAN FROM MAN. NEITHER WAS MAN MADE FOR WOMAN, BUT WOMAN FOR MAN.
> —NEW TESTAMENT, 1 CORINTHIANS 11:3-10
>
> LET THE WOMAN LEARN IN SILENCE WITH ALL SUBJECTION. BUT SUFFER NOT WOMAN TO TEACH, NOR TO USURP AUTHORITY OVER THE MAN, BUT TO BE IN SILENCE.
> —NEW TESTAMENT, 1 TIMOTHY 2:11-12
>
> IF [A WOMAN] DOES NOT GO JUST AS YOU WANT HER TO, CHASE HER FROM YOUR BED, GIVE HER A DIVORCE, AND LET HER GO.
> —APOCRYPHA, ECCLESIASTES 25:13-26

Let us now praise Middle Aged women, who weren't all damsels in distress, waiting for their knights in shining armor. In classical civilizations, women were the virtual prisoners of the men in their lives, but medieval women took part in almost every aspect of public life. Despite biblical teachings against them, they became writers, artists, merchants, and nuns, and ran the kingdom when their husbands were away at war. Joan of Arc, a teenaged French cross-dresser, led her country's army into battle…and won.

By the 4th century, the emperors of Rome had converted to Christianity, and the religion spread throughout the empire. By the end of the first millennium, Western Europe had evolved into a network of feudal Christian cities and kingdoms. Rich, powerful nobles owned the land and battled other nobles to get more of it. Serfs and slaves owed their lives and allegiances to the lord whose wealth they produced. War and defense were major concerns: rural lords lived in walled castles, and urban lords in fortified cities. Righteous combat was a virtue: the forces of good (us) squared off against the forces of evil (them).

Art in the Middle Ages became a didactic tool of the church. The great cathedrals, built over centuries, presented Bible stories and doctrine to the illiterate masses. Most art history surveys concentrate on these awesome cathedrals, giving the impression that they are the most important artistic achievement of their time. But many other arts flourished: religious objects, illuminated manuscripts, and tapestries, to name a few, all made by artists working in guilds, collective workshops, and religious communities. These nameless artists labored in the service of abbots, abbesses, kings, and nobles, who dictated the content of the work and directed its production.

Many of these artists were women, either working in businesses owned by male family members or living as nuns in convents. By the 15th century in Bruges, for example, 25 percent of the members of the illuminators' guild were female. Records tell us there were many women sculptors, too: the 12th-century Spanish cross by Sanccia Guidisalvi (right) is a rare surviving example.

SANCCIA GUIDISALVI, SPANISH PROCESSIONAL CROSS, 12TH CENTURY, THE METROPOLITAN MUSEUM OF ART, NEW YORK, GIFT OF J. PIERPONT MORGAN

19

Few of these artists signed their work, so it's not easy to attribute specific works to individual artists. Instead it is the patrons, whose names were recorded, who get the credit. For once, male artists are as forgotten as the females.

Although it's hard to attribute medieval art, there *are* works by women we know about. Ende, a nun in 8th-century Spain, helped illuminate a book on the Apocalypse. Guta, a 12th-century German nun, collaborated with a monk on the Sermons of Saint Bartholomew (see page 22). A book of Psalms from 12th-century Germany contains an image of a woman swinging on the letter *Q*, signed Claricia and thought to be a self-portrait (right). A rarely acknowledged fact is that the much-admired 14th-century manuscripts by Jean Le Noir, including works commissioned by the Duc du Berry, were done in collaboration with his daughter, Bourgot.

One of the "masterpieces" of medieval art is the Bayeux Tapestry. We prefer to call it a mistresspiece, because it was made entirely by women needleworkers.

A STITCH IN TIME: THE BAYEUX TAPESTRY

The Bayeux Tapestry, a banner over 200 feet long, is considered one of the most important medieval art objects surviving to the present day. Its embroidery tells the story of the conquest of England by the Norman king William the Conqueror, in

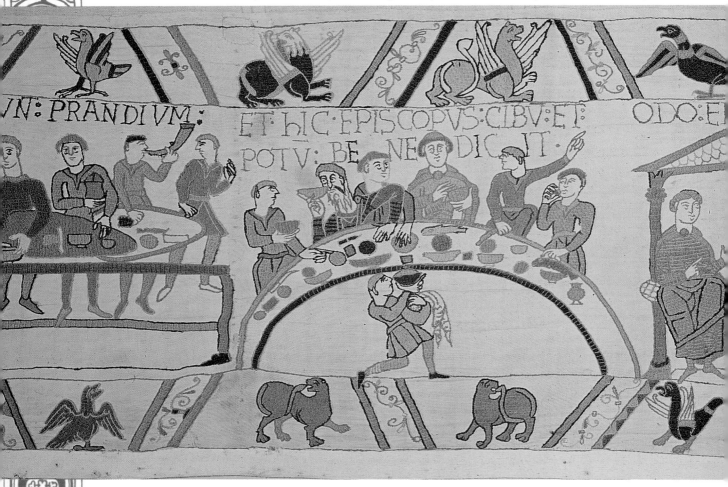

1066. It contains a myriad of depictions of everyday life and is unusual for its time because its subject is secular, not religious. Exactly when and where it was made and who commissioned or designed it are questions scholars have debated endlessly. But they all agree that it was embroidered by women, probably from the Kentish area of England. At a time when most medieval artists were copyists, diligently duplicating the look and content of already existing works, the Bayeux Tapestry is unique in both subject matter and style.

Notice how skillfully the needlewomen rendered the actions of war and the interactions of kings and generals (left). One scholarly book on the tapestry goes on and on about its historical and formal sources, but completely ignores the women who executed it. Instead, the author assumes the tapestry to be the design of a single male genius who hired it out to insignificant sewers. The author is preoccupied with discovering the nationality of "the master artist," continually referred to as "he." Guerrilla Girls Art Historical Investigative Service advice: don't be a private dick, *cherchez les femmes!*

Because much of the information on individual artists in the Middle Ages is lost forever, we've decided to focus on two women who commissioned artists to illuminate their books: Hildegard von Bingen, a German nun, and Christine de Pizan, a French court writer.

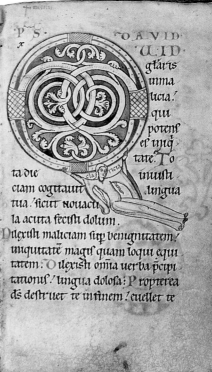

CLARICIA, GERMAN PSALTER, 12TH CENTURY. WALTERS ART GALLERY, BALTIMORE

SISTERHOOD IS POWERFUL: HILDEGARD VON BINGEN

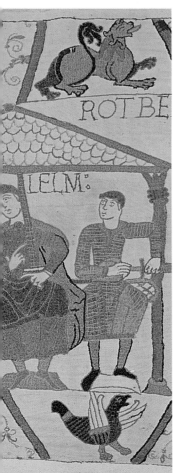

Joining a convent freed women from the demanding roles of being wives and mothers. Families sent girls as young as five or six years old to nunneries. For some it was to live a religious life, for others it was because their parents had blown the family fortune on their sisters' dowries. Adult women with pasts to be forgotten joined religious orders too, as did reformed prostitutes. There, they lived a life by, for, and about God…and women.

In Germany by the 12th century, many convents had become complete communities of women, separate from the male monasteries. A class structure was in place: they were run by powerful abbesses from noble families, often the sisters of leaders like Charlemagne and Otto, and women of lower social class formed the rank-and-file. These nuns had an autonomy unknown to their sisters on the outside.

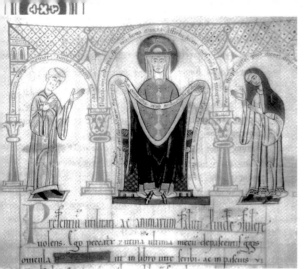

They operated businesses, farmed, made tapestries, copied and illustrated manuscripts, composed and performed music. And they educated one another.

Nuns wrote books on medicine, science, and sacred music. Many claimed to have mystical visions in which God spoke directly to them, revealing truths about the nature of Christian faith and salvation. They dictated these visions to scribes, and had artists illustrate them. These manuscripts traveled all over, spreading their ideas. The mystical experiences were lauded by the male clergy because they represented the emotional, nonrational side of the female sex. And they gave the nuns an important voice in the church that they would not have had otherwise.

GUTA, A NUN (RIGHT), AND SINTRAM, A PRIEST (LEFT), COLLABORATORS ON THE CODEX SINTRAM GUTA, C. 1154, STAND BESIDE THE VIRGIN MARY

What women who weren't nuns could and couldn't do in the Middle Ages

•Women were usually engaged to be married at age 12, and were married by 15. If an engaged girl married another man, she could be killed.

•A woman was required to be faithful to her husband, and adultery could be punished by flogging or being buried alive. Husbands were allowed to commit adultery, unless it was with another man's wife.

•A wife could divorce her husband only if he was a pederast or forced her to have sex with another man, while a man could divorce his wife if she couldn't bear children or if he was willing to return her dowry.

•Education was thought to interfere with a woman's ability to be a good wife and mother. Almost no women were taught to read and write.

•Almost all women worked in some family business, but the fruits of their labors belonged to men—their fathers, husbands, or brothers.

•A woman had to obey her husband, and he could beat her if she didn't.

But sooner or later, uppity women always get into trouble. When nuns' visions started containing warnings against sin and corruption within the priesthood, the church administration found the sisters too hot to handle. Eventually, the most independent convents were shut down or taken over by priests.

Hildegard von Bingen was one of these maverick nuns, along with Gertrude of Helfta, Mechtild of Hackeborn and Mechtild of Magdeburg. On the next two pages is Hildegard's life told as an illuminated manuscript.

THE PEN IS MIGHTIER THAN OTHER THINGS THAT START WITH A "P": CHRISTINE DE PIZAN

Christine de Pizan, the first woman known to have made her living as a writer in the Middle Ages and a single mom to boot, would have been extraordinary in any age.

Born about 1364 in Venice, she was the daughter of a physician and professor of astrology. Her father moved the family to Paris when he became an adviser to the French court. Christine spent the rest of her life in France. Despite the protestations of her mother, she was educated by her father. At fifteen, she was married to another enlightened man, who encouraged her to continue a scholarly life.

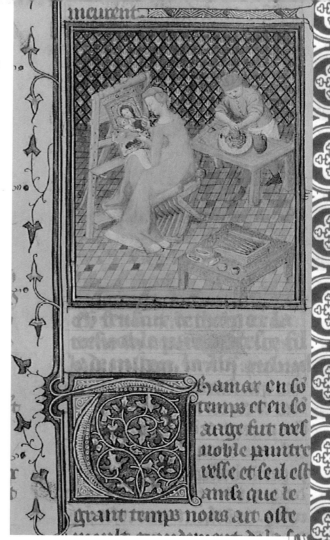

THAMAR PAINTS A PICTURE AS HER MALE ASSISTANT MIXES THE COLORS IN A 1402 COPY OF BOCCACCIO'S *DES CLERES ET NOBLES FEMMES*, BIBLIOTHÈQUE NATIONALE DE FRANCE

But alas, Christine was widowed at twenty-five, with several children to support, a disapproving mother, and no inheritance (it had been claimed by her brothers). She had no choice but to make her living by her wits and her pen. First she became a copyist of other written works (this was just before the invention of the printing press). Then she began writing poems, ballads, and allegories for aristocratic patrons. Many of these works were illustrated under her direction, then copied and passed around Europe. At least one of the artists she employed was a woman, Anastaise, about whom Christine proclaimed, "...one cannot find an artisan in all the city of Paris–where the best in the world are found–who can surpass her!" Christine was famous and influential during her lifetime and for centuries after.

It was a courageous act for a woman to be an outspoken intellectual in an era when females were thought to be morally inferior and incapable of reason or logic. To be anything even approaching a feminist was unheard of in Christine's time, but she was not afraid to attack well-known men who belittled women. In 1405, she let it rip in the notorious debate over *The Romance of the Rose,* a popular poem about love written a century earlier by Guillaume de Lorris and Jean de Meung. In it, a young man is advised to take advantage of women, because they are by nature

In 1106, at the age of eight, Hildegard was sent by her wealthy parents to a convent at Disibodenberg, Germany. Already, she had begun to see shimmering lights and circling stars. She received training in Scripture, Latin, and music, took her vows in the Benedictine order and was elected abbess in 1136.

In her forties, she recorded her visions in her first book, *Scivias* (Know the Ways). She had put off starting it "because of doubt and erroneous thinking and because of controversial advice from men." Then, "Beaten down from many kinds of illnesses, I put my hand to writing. Once I did this, a deep and profound exposition of books came over me. I received the strength to rise up from my sickbed, and under that power I continued to carry out the work to the end."

She worked on *Scivias* for ten years, and had it illuminated by artists unknown to us now. In it, she presented 35 of her mystical experiences. Later she set part of *Scivias* to music, then dictated two more books of visions, wrote 63 hymns with music, a miracle play, a long treatise on natural history, and a book on medicine. She corresponded with many powerful and learned people and traveled all over Europe.

(Some modern men of medicine have attributed the intensity of her visions to a bad case of migraines. Ideas like that give Guerrilla Girls a headache.)

In her writings, Hildegard urged Christians to lead a more spiritual life and nuns and priests to uphold their vows of poverty, chastity, and obedience. SCIVIAS was shown to the Pope and he gave her his blessing. His approval made Hildegard famous and her convent became so crowded that she had to move it to a larger site, in Rupertsberg, near Bingen.

Near the end of her life, Hildegard's independent ideas infuriated the Church higher-ups, and she was placed in house arrest in her abbey.

Just before she died, in 1179, she had her last vision, in which two streams of light appeared in the sky and crossed over the room in which she lay ill.

"I saw the image of a woman of great size—just as a great city is...Her womb was full of holes, much like a net, and a great crowd of people were moving about in it...Her breasts were surrounded with such splendor that they shone as a reddish dawn full of reddish lightning...Next...infants entered her womb through the many holes that were in it. This woman then sighed, drawing the infants up to her head, where she breathed them forth through her mouth, remaining pure in the process...And the woman, looking at them most kindly, said to them sadly, 'My very own children are turning back into dust. Nevertheless, I conceive and bear many who tire and oppress me, their mother, with their various...heresies and schisms and useless battles, in plunderings and in murders, in adulteries and fornications and in other errors similar to these."
—Hildegard von Bingen,
The Fifth Vision of the Second Part, from SCIVIAS

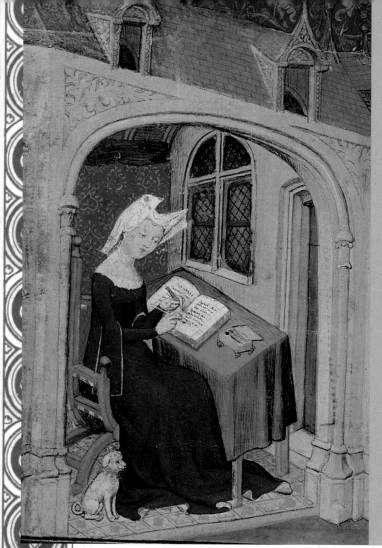

BAD GIRLS... TALKING 'BOUT SAD GIRLS

We think Christine de Pizan pretty well describes the difficulties women face, even today, in taking themselves—and in being taken—seriously. Some things never change. Don't despair, however. Christine didn't really lose faith in women. She was just laying a coy foundation to blow the misogynists away.

[I] WONDER HOW IT HAPPENED THAT SO MANY LEARNED MEN...ALL CONCUR IN ONE CONCLUSION: THAT THE BEHAVIOR OF WOMEN IS INCLINED TO AND FULL OF EVERY VICE. I CONSIDERED OTHER WOMEN WHOSE COMPANY I FREQUENTLY KEPT, PRINCESSES, GREAT LADIES, WOMEN FROM THE MIDDLE AND LOWER CLASSES, HOPING I COULD JUDGE IMPARTIALLY... WHETHER THE TESTIMONY OF SO MANY NOTABLE MEN COULD BE TRUE....I COULD NOT SEE HOW THEIR CLAIMS COULD BE TRUE....YET...IT WOULD BE IMPOSSIBLE THAT SO MANY FAMOUS MEN COULD HAVE SPOKEN FALSELY ON SO MANY OCCASIONS....I COULD HARDLY FIND A BOOK ON MORALS...[WHERE] I DID NOT FIND SEVERAL CHAPTERS...ATTACKING WOMEN...AND I FINALLY DECIDED THAT GOD FORMED A VILE CREATURE WHEN HE MADE WOMAN...A GREAT UNHAPPINESS AND SADNESS WELLED UP IN MY HEART, FOR I DETESTED MYSELF AND THE ENTIRE FEMININE SEX, AS THOUGH WE WERE MONSTROSITIES IN NATURE.

—CHRISTINE DE PIZAN, INTRODUCTION TO THE CITY OF LADIES

CHRISTINE DE PIZAN IN HER STUDY, FROM THE CITY OF LADIES, HARLEY 4431 F.4, BY PERMISSION OF THE BRITISH LIBRARY

so wanton and dishonorable. Christine attacked the work, although lots of her influential friends tried to dissuade her from her position. She was enraged by guys who espoused bigoted ideas about women and then thought themselves to be advanced and enlightened for it.

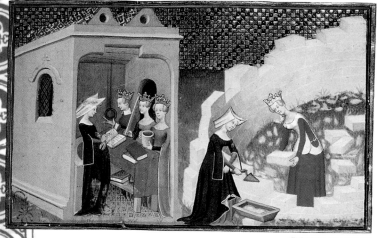

"THE BRICKLAYERS," FROM THE CITY OF LADIES, HARLEY 4431 F. 290, BY PERMISSION OF THE BRITISH LIBRARY

Hot under her elaborate lace collar, Christine crafted her arguments against the sexist scholars of her day into The City of Ladies (1405), a long allegory describing an entire city populated by the bravest, strongest, most virtuous women from history. In it, three beautiful women personifying Reason, Rectitude, and Justice describe how the city of ladies is to be built and which heroines from the Bible, Greco-Roman mythology, and history would live there. She even goes on at great length about those fearless female Guerrillas, the Amazons.

By the end of her life, Christine had produced hundreds of ballads, lyrics, pastoral poems, and other forms of short verse. She also wrote longer poetic works, on the virtues of women and courtly love, didactic treatises on moral instruction, the education of women, warfare, chivalry, and politics, and letters to the prominent people of her day.

Her last work was a poem composed in 1429 in tribute to another early Guerrilla Girl, Joan of Arc. At that time Christine was living in exile in her daughter's convent, having fled there 10 years earlier to escape a civil war that deposed her royal patron.

Joan of Arc was a young, religious girl from Orléans, France, often called the "Maid" or "Virgin of Orléans" (how did they know?). Like Hildegard, she had visions and heard voices telling her to save her country. She cross-dressed as a knight and rallied the armies of France to expel the English pretender to the throne. Then she saw to it that Charles VII was reinstated as king. This was the same Charles who was Christine's sacked patron, so it follows that Christine thought of Joan as her personal savior as well as the savior of France. But she also saw Joan as the redeemer of womanhood:

> Oh! what honor for the female sex!
> It is perfectly obvious that God has special regard for it
> when all these wretched people who destroyed a whole kingdom–
> now recovered and made safe by a
> woman–
> something that 5000 men could not
> have done….
> Before the event they would have
> scarcely believed this possible.

Christine died in exile, before Charles was back in charge. Joan stood next to Charles at his coronation, then he turned her over to English sympathizers, who branded her a witch and a heretic. She was burned at the stake in 1431 for those offenses, and also because she refused to stop wearing men's clothes. Eventually the church made her a saint.

JOAN OF ARC BEING TAKEN PRISONER, BIBLIOTHÈQUE NATIONALE DE FRANCE

Christine de Pizan and Hildegard von Bingen led lives far from what was expected of women in the Middle Ages. Roll over, Leonardo et al.: Guerrilla Girls believe that they were the first Renaissance (Wo)Men.

THE RENAISSANCE:

LIVES OF THE GIRL ARTISTS

Guerrilla Girls don't want to say anything bad about geniuses of the Italian Renaissance like Michelangelo, Leonardo, Raphael, or Caravaggio, but let's face it, it's guys like them who made things tough for women artists. Starting with them, art history is written as the story of one heroic white male artist following another. A few masters and their masterpieces come to represent an entire era. Historians fight over who was the greatest artist of each era, as though there was an aesthetic Olympics where only the winners count. Everyone assumes that art in the Renaissance was an all-guys' game. Hold on to your seats, because that just isn't true.

During the Renaissance in Italy, artists usually came from the social class of artisans, without wealth or property. They had to go through an apprenticeship with another, established artist, then join a guild, a kind of union (later these would become academies), and set up an atelier or workshop of their own. If they were very successful and won commissions from the richest, most influential patrons and from the church, they might even make a claim to nobility, as Michelangelo did. A few artists, like Vasari, were from aristocratic families, which gave them a head start.

This whole system was, of course, closed to women. In most cities, women were barred from painters' guilds or academies (except for the lace and silkmakers' guilds). They couldn't receive commissions or legally own an atelier. Most were illiterate. One of the few ways a woman could work as an artist was to be born into a family of artists that needed assistance in the family workshop. A rare exception to this was Sofonisba Anguissola, a noble whose father believed women should be educated. He sent one of her drawings to Michelangelo. The ateliers of many of the great "masters" were filled with their wives, sisters, and daughters, grinding out the masters' oeuvre. Some of these women, including those who follow, figured out how to establish themselves as independent artists.

Lavinia Fontana worked in her father's studio in Bologna. He allowed her to marry another painter, provided the couple lived with him and forked over all the money

A LOT OF WOMEN'S ART IS BOLOGNA

THE CITY OF BOLOGNA STOOD OUT FROM THE REST OF EUROPE IN ITS ATTITUDE TOWARD WOMEN. WOMEN WERE ADMITTED TO ITS UNIVERSITY BEGINNING AS EARLY AS THE 13TH CENTURY AND WERE EVEN PERMITTED TO LECTURE THERE (ALTHOUGH NOVELLO D'ANDREA HAD TO SPEAK TO STUDENTS FROM BEHIND A SCREEN TO AVOID "DISTRACTING THE STUDENTS WITH HER PERSONAL CHARMS"). THE CITY PRODUCED MANY LEARNED WOMEN IN PHILOSOPHY AND LAW. ITS PAINTERS' GUILD HAD A FEMALE PATRON, CATERINA VIGRI, AN ARTIST NUN WHO LATER WAS CANONIZED AS SAINT CATHERINE OF BOLOGNA. THERE WAS EVEN A SCHOOL FOR WOMEN ARTISTS, FOUNDED BY THE PAINTER ELISABETTA SIRANI. AND GUESS WHAT...THERE WERE MORE WOMEN ARTISTS IN BOLOGNA DURING THIS TIME THAN ANYWHERE ELSE IN ITALY. IF ALL ITALIAN CITIES HAD BEEN SO OPEN, IMAGINE WHAT A DIFFERENT RENAISSANCE THERE MIGHT HAVE BEEN!

she earned. She gave birth to eleven children while continuing to work. The Pope asked her to Rome, but she was such a good daughter that she had to wait until her father died before she went.

Elisabetta Sirani, another Bolognese artist, was so accomplished a painter that she was accused of signing work her father had done. To prove the wags wrong, she began painting in public and eventually opened a school for women artists.

Onorata Rodiani abandoned a promising career as a painter when she killed a colleague who tried to rape her. Rather than stand trial for murder, she fled and spent 20 years in drag as a professional soldier. Her real sex was discovered at her death.

Amilcare Anguissola had six daughters and one son. All the girls were taught to paint. His most famous daughter, Sofonisba, worked for years at the Spanish court. Because she wasn't married, she was the ward of her patron, the king. When she was fifty-two, he

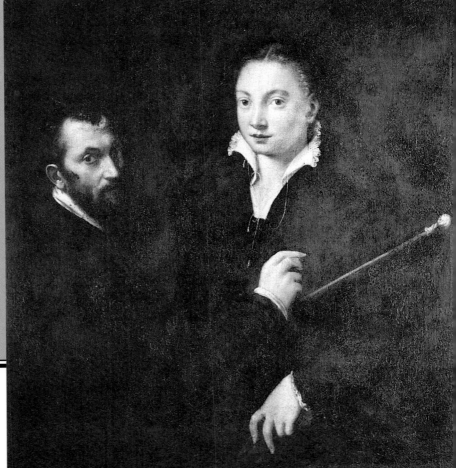

SOFONISBA ANGUISSOLA, *BERNARDINO CAMPI PAINTING SOFONISBA ANGUISSOLA*, LATE 1550'S, PINACOTECA NAZIONALE, SIENA, ALINARI/ART RESOURCE, NEW YORK

When we think of a "Renaissance man," we imagine a guy who could do anything and everything and was way ahead of his time in knowledge and abilities. In fact, a real "Renaissance man" would not get to first base with most 20th-century women.

A REAL RENAISSANCE MAN:

- BELIEVED THAT SOCIAL CLASS WAS EVERYTHING.

- DIDN'T MARRY A WOMAN FOR LOVE, BUT FOR HER DOWRY.

- THOUGHT IT WOULD BE DANGEROUS IF FEMALES LEARNED TO READ OR WRITE.

- THOUGHT THE BEST WAY TO SETTLE A DISPUTE WAS TO KILL A RIVAL IN A DUEL.

- CONSIDERED THE SEDUCTION OF A VIRGIN A HORRIBLE CRIME BUT THE RAPE OF A WIDOW NO BIG DEAL.

- WAS CONVINCED THAT WOMEN WERE DESTRUCTIVE TO THE CREATIVE PROCESS.

- WAS CERTAIN THE WORLD WAS FLAT.

MICHELANGELO, *DAVID*, 1501-1504, ACCADEMIA, FLORENCE

married her off to a Sicilian. When her husband died, she was to return to Spain, but ran off with the captain of the ship she was taking.

Properzia de Rossi is the only known Renaissance woman to have sculpted in marble. She began by carving miniatures on cherry stones, but soon went after bigger fruit. In 1520, she won a commission to produce marble sculptures for the Church of San Petronio in Bologna. Her situation was unusual: she lived on her own with no man to look after her. This gave people plenty to talk about, and eventually she was accused of being a prostitute. This ruined her. She died, penniless, only four years after receiving her last payment for San Petronio.

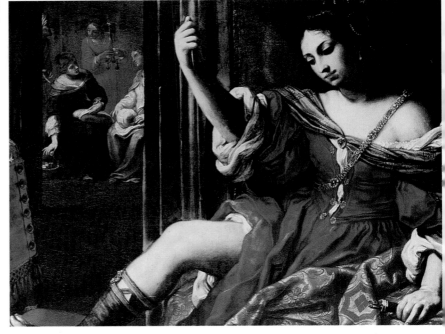

Giorgio Vasari was a 16th-century painter who wrote about the art of his time in *Lives of the Artists*. He included several women in its various editions. We decided to do our own version, *Lives of the Girl Artists,* in 20th-century comic book form, featuring Maria Robusti and Artemisia Gentileschi (see following pages).

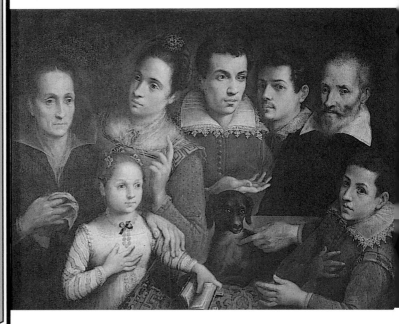

What a woman was allowed to do in the Renaissance:

· SHE COULD DIVORCE HER HUSBAND ONLY IF SHE COULD PROVE HIM IMPOTENT.

· SHE COULD SALVAGE HER REPUTATION BY MARRYING ANY MAN WHO RAPED HER.

· SHE COULD ATTEND OR TEACH IN A UNIVERSITY IF SHE MOVED TO BOLOGNA.

· SHE COULD GET A LEGAL ABORTION SANCTIONED BY THE CATHOLIC CHURCH, BUT THE PRIMITIVE PROCEDURE COULD KILL HER.

· SHE COULD WEAR UNDERWEAR ONLY IF SHE WAS AN ARISTOCRAT, A PROSTITUTE, AN ACTRESS, OR A WINDOW WASHER.

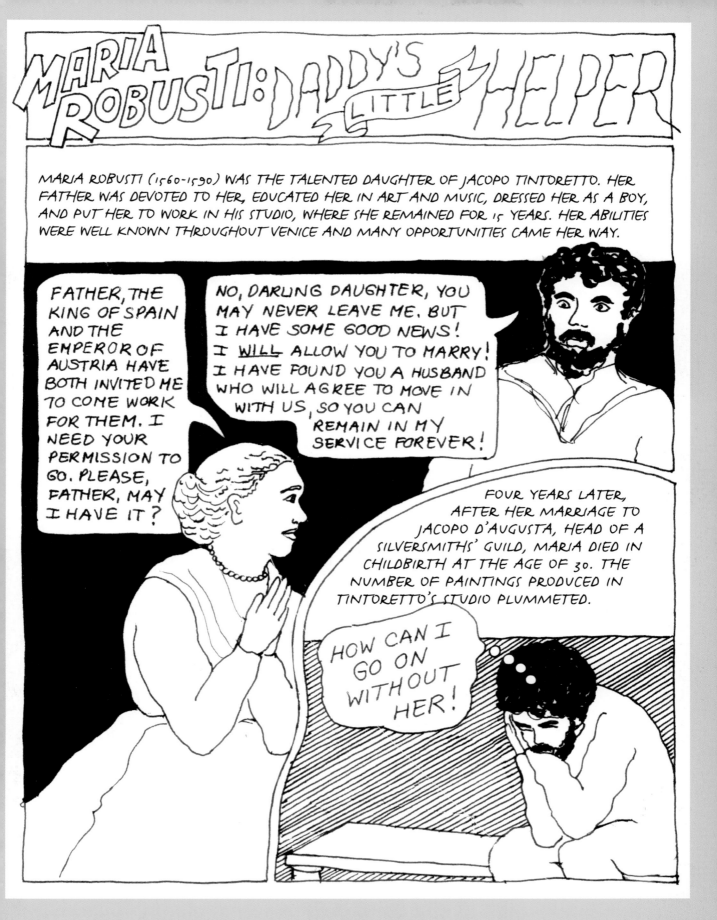

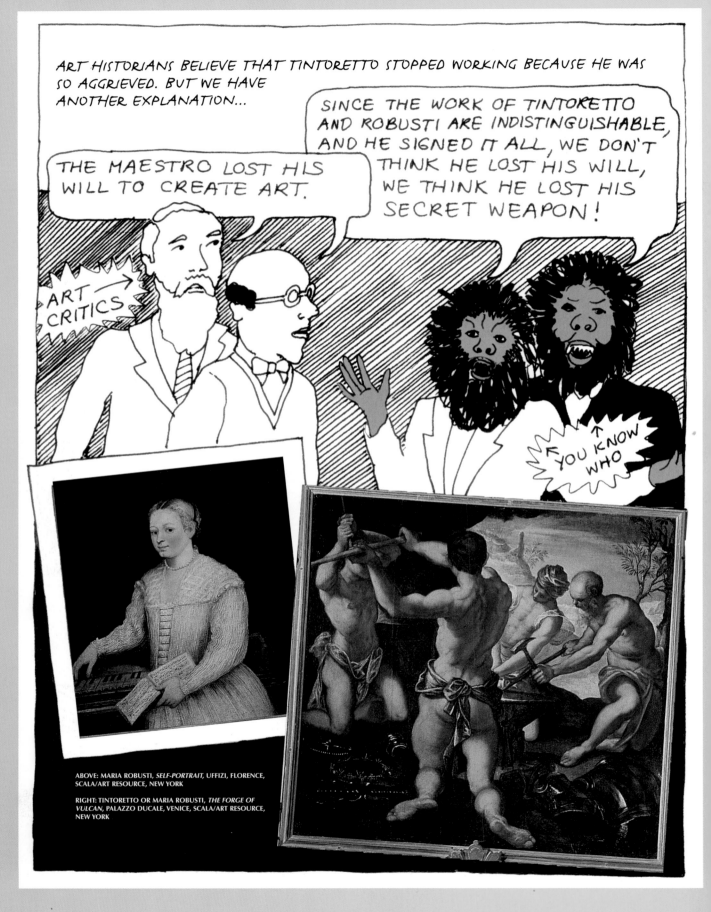

ABOVE: MARIA ROBUSTI, *SELF-PORTRAIT,* UFFIZI, FLORENCE, SCALA/ART RESOURCE, NEW YORK

RIGHT: TINTORETTO OR MARIA ROBUSTI, *THE FORGE OF VULCAN,* PALAZZO DUCALE, VENICE, SCALA/ART RESOURCE, NEW YORK

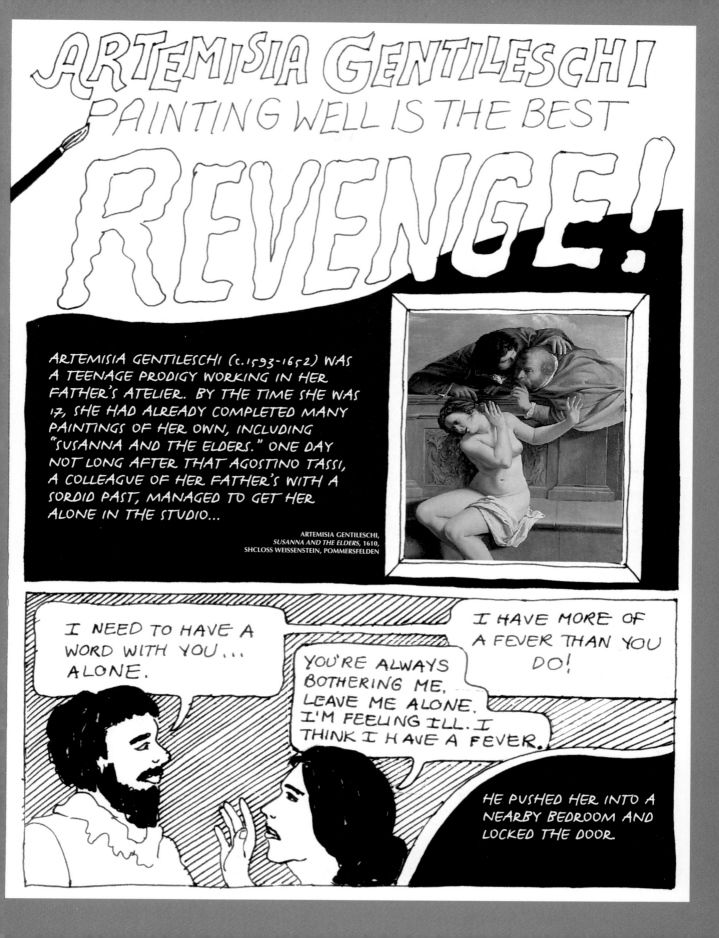

AFTER HE RAPED HER, THE ROGUE PROMISED TO MARRY HER TO SAVE HER REPUTATION (WHICH ACCORDING TO THE CUSTOM OF THE TIME WOULD ERASE THE CRIME). BECAUSE OF THE PROMISE, SHE FELT COMPELLED TO CONTINUE HER RELATIONSHIP WITH HIM. WHEN AGOSTINO RENEGED ON THE MARRIAGE, ARTEMISIA'S FATHER BROUGHT A LAWSUIT AGAINST HIM. (WOMEN WERE NOT ALLOWED TO BRING CHARGES IN COURT.) ARTEMISIA WAS QUESTIONED AND LATER TORTURED TO MAKE SURE SHE WAS TELLING THE TRUTH.

WHAT DID HE DO TO YOU?

HE THREW ME ONTO THE EDGE OF THE BED, LIFTING MY CLOTHES, WHICH HE HAD A GREAT DEAL OF TROUBLE DOING, HE PLACED A HAND ON MY MOUTH TO KEEP ME FROM SCREAMING, HAVING PREVIOUSLY PUT BOTH KNEES BETWEEN MY LEGS. WITH HIS PENIS POINTED AT MY VAGINA, HE BEGAN TO PUSH IT INSIDE. IT HURT VERY MUCH. I SCRATCHED HIS FACE AND PULLED HIS HAIR AND BEFORE HE PENETRATED ME AGAIN I GRASPED HIS PENIS SO TIGHT THAT I EVEN REMOVED A PIECE OF FLESH. AFTER HE HAD DONE HIS BUSINESS, HE GOT OFF ME. WHEN I SAW MYSELF FREE, I TOOK A KNIFE AND MOVED TOWARD AGOSTINO, SAYING, "I'D LIKE TO KILL YOU WITH THIS KNIFE BECAUSE YOU HAVE DISHONORED ME. TO PACIFY ME, HE SAID, "GIVE ME YOUR HAND, I PROMISE TO MARRY YOU." HE ADDED, "I WARN YOU THAT WHEN I TAKE YOU [AS MY WIFE] I DON'T WANT ANY FOOLISHNESS. *

*FROM THE TRIAL DOCUMENTS, 1612, TRANSLATED BY EFREM G. CALINGAERT, IN MARY D. GARRARD'S *ARTEMISIA GENTILESCHI*

DID YOU BLEED AFTER THE RAPE?

AT THE TIME WHEN THE SAID AGOSTINO VIOLATED ME, I WAS HAVING MY MENSTRUAL PERIOD AND, THEREFORE, I CANNOT TELL YOUR LORDSHIP FOR CERTAIN WHETHER I WAS BLEEDING BECAUSE OF WHAT AGOSTINO HAD DONE BECAUSE I DON'T KNOW MUCH ABOUT THOSE THINGS. WHEN I ASKED HIM WHAT THE BLOOD MEANT, HE SAID IT CAME BECAUSE I HAD A WEAK CONSTITUTION. *

THE TRIAL WAS VICIOUS. AGOSTINO BROUGHT IN WITNESSES CLAIMING THAT ARTEMISIA WAS A WOMAN OF NO VIRTUE. IT WAS ALSO DISCOVERED THAT AGOSTINO HAD A LONG CRIMINAL RECORD, HAD HIS WIFE MURDERED AND TRIED TO STEAL PAINTINGS FROM ARTEMISIA'S FATHER. AGOSTINO WAS IMPRISONED AND ARTEMISIA'S REPUTATION RESTORED. A YEAR LATER, HE WAS FREED FROM JAIL AND RESUMED HIS DISSOLUTE LIFE. EVENTUALLY HE WENT BACK TO WORK FOR ARTEMISIA'S FATHER.

AFTER THE TRIAL (AND SOME SAY BECAUSE OF IT) ARTEMISIA WENT ON TO LIVE AN UNUSUALLY AUTONOMOUS LIFE FOR A WOMAN OF HER TIME. SHE SOMEHOW WAS ABLE TO SET UP HER OWN ATELIER, LEARNED TO READ AND WAS THE FIRST FEMALE MEMBER ADMITTED TO THE ACCADEMIA DEL DISEGNO. SHE MARRIED A WEALTHY FLORENTINE PAINTER AND HAD A SON. HERE SHE IS IN 1620 WORKING ON HER MOST FAMOUS PAINTING, "JUDITH SLAYING HOLOFERNES," THE BIBLICAL STORY OF A JEWISH WOMAN WHO KILLS AN ASSYRIAN GENERAL, AN ENEMY OF HER PEOPLE, BY PRETENDING TO SEDUCE HIM.

MANY ARTISTS SHOW JUDITH LOOKING AWAY AS SHE CUTS OFF HOLOFERNES' HEAD. THEY THINK A WOMAN COULD NOT BEAR TO LOOK WHILE DOING SUCH A DEED. I WILL SHOW JUDITH INTENT ON ACCOMPLISHING HER MISSION, AND UNAFRAID TO FACE CARNAGE AND DEATH. AGOSTINO..., THIS ONE'S FOR YOU!!!

ARTEMISIA GENTILESCHI, JUDITH SLAYING HOLOFERNES, C. 1620, UFFIZI, FLORENCE, SCALA/ART RESOURCE, NEW YORK

IN LATER YEARS, ARTEMISIA, APPARENTLY LIVING AS A SINGLE MOTHER, TRAVELED ALL OVER ITALY, WAS A COURT PAINTER TO THE KING OF ENGLAND, COUNTED COSIMO DE MEDICI AND EMPRESS MARIA OF AUSTRIA AMONG HER PATRONS AND CORRESPONDED WITH FAMOUS MEN OF HER TIME LIKE GALILEO. SHE DID MANY MORE PAINTINGS ON THE THEME OF JUDITH AND HOLOFERNES.

THE 17TH AND 18TH CENTURIES:

ENGENDERED SPECIES

During the 17th and 18th centuries, Europe colonized the Americas, Africa, and Asia. A vicious African slave trade grew to provide cheap labor and vast profits in the "new world." Powerful monarchies fought each other for territory and so did intellectual movements like the Enlightenment, neoclassicism, and Romanticism. Yearnings for democracy culminated in revolution in the U.S. and France. But even revolutionary thinkers like Rousseau saw a woman's place, according to both "nature" and "reason," to be in her home, taking care of those around her.

Art took off in many directions. In England, France, and Italy, royal academies controlled commissions from aristocrats and eventually strangled artists with aesthetic prescriptions and rules. Neoclassicism, with its insistence on heroic, larger-than-life themes from history and mythology, held sway in most of these academies, and artists' reputations depended on how well they could do that kind of art. One prerequisite was knowing how to draw from live nude models, especially males, something women were forbidden to do. How was a girl to make an important painting if she didn't know a guy's ass from his elbow?

Up in the Netherlands, heroic subject matter wasn't as important. There were new patrons from a growing class of wealthy merchants who wanted paintings that showed off their material possessions. Depictions of everyday life were valued and naked bodies weren't. As a result, there were more women

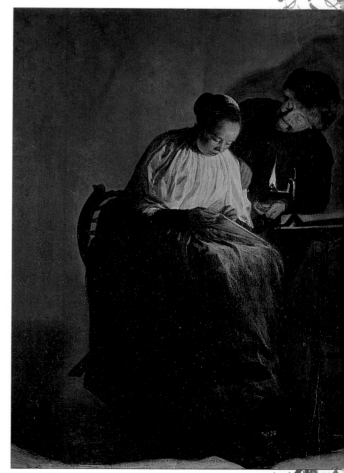

JUDITH LEYSTER, *THE OFFER REFUSED*, MAURITSHUIS, THE HAGUE, SCALA/ART RESOURCE, NEW YORK

artists in Holland than in the rest of Europe, many of them very successful in their lifetimes. Of course, after they died they were soon dismissed by art history: a comprehensive 20th-century study of Netherlandish painting by Walter Bernt includes only 6 women out of 800 artists.

While the male academics were off painting the "important" subjects of war and the gods, most women artists of the 17th and 18th centuries kept the home fires burning, perfecting the areas where they were allowed to excel: still life and portraiture. There were a few girl artists who tried to beat the guys at their own game, history painting. What a heroic effort that turned out to be (see Angelica Kauffmann, page 43).

JUDITH LEYSTER: DECK THE HALS

Judith Leyster (1609-1660) was the daughter of a brewer in Haarlem. In 1629 she apprenticed herself to Frans Hals, a well-known Dutch painter. By 1633, she was a member of the Painters' Guild. She also is known to have had three male students, which means she had a good reputation. She even had the nerve to later sue Frans for accepting a student who had left her. Then she married a painter, had three children, and had a lot less time to make art. By the time she died she was unknown. Over time, her work was attributed to several males in her life, including her husband and her teacher, Frans. In the 1890s, her

WHERE THERE ARE MEN, THERE ARE WOMEN...

There were at least two painters of African descent in 17th-century Spain. Juan de Pareja (1606-1670) was a slave of Diego Velázquez, who taught him to paint and eventually freed him. His work is sometimes mistaken for his teacher's, and Diego did a famous portrait of him. Juan then married a relative of Diego's. Sebastian Gomez (1646-1682) was the slave of Bartolomé Murillo. He was caught painting at night, then given a job in the studio. He won commissions while enslaved and never left Bartolomé's household. We haven't found any records of women artists of African heritage in Europe before the 19th century, but that doesn't mean there weren't any. We bet scholars will discover them soon.

signature was noticed on a number of paintings sold to major museums as Frans's, one of them described as "one of the finest he ever painted." After these paintings were reattributed to Judith, art historians suddenly realized that they weren't so fine after all: in 1964, art historian James Laver said, "Some women artists tend to emulate Frans Hals, but the vigorous brush strokes of the master were beyond their capability. One has only to look at the work of a painter like Judith Leyster to detect the weakness of the feminine hand." Guerrilla Girls think he should have his eyes examined.

ANNA MARIA SYBILLA MERIAN: THE ORIGINAL SPIDER WOMAN

Maria Merian (1647-1717) was born in Germany but spent most of her life in Holland. Her father was a Swiss engraver, and when he died her mother married a Dutch flower painter. From an early age, Maria was interested in animal and plant life. She married her art teacher and published several volumes of hand-painted flower engravings, meant to be used as embroidery patterns. Later she did books on European insects, drawing them by observing live specimens. This was an important advance for botanical and zoological studies, and paved the way for the scientific classification of species. In 1685 she dumped her husband and joined a religious sect, the Labidists, who didn't believe in marriage or worldly goods. She and her two daughters took off for Surinam to document the insects and flowers there. Her *Metamorphosis Insectorum Surinamensium* appeared in 1705, with engravings based on her watercolors, and was translated into several languages. It is considered one of the finest works of botanical illustration ever. Maria died in poverty, but her daughters continued the work she started. Was her work art or science? This reminds us of the question we're always asked: Is Guerrilla Girls' work politics or art? We hereby declare that all art is art, whether it's scientific, political, or anything else.

MARIA SYBILLA MERIAN, *METAMORPHOSIS INSECTORUM SURINAMENSIUM*, AMSTERDAM, GETTY RESEARCH INSTITUTE, RESOURCE COLLECTIONS, LOS ANGELES

What it was like for women in the 17th and 18th centuries:

·Girls as young as 12 were sent away from home to labor long hours in the textile and garment trades.

·If you were rich or middle class and one of your sisters got married first, your parents would probably blow their fortunes on her dowry, leaving you nothing, and you'd never marry.

·One out of ten women died in childbirth.

·If you were poor, a last-ditch employment option was to become a wet nurse.

·As much as 15 percent of the adult female population were prostitutes.

·A woman who had children out of wedlock could be dismissed from her job or sent to a prison.

·Four times as many women were accused of being witches as men.

HOW THE WORD "ACADEMIC" GOT ITS BAD NAME

Academies evolved from guilds, which, beginning in the Middle Ages, provided a network for artisans to get training and jobs. By the 18th century, academies ruled the art world. Membership was limited and for life, guaranteeing success for members and hard times for everyone else. The French Academy demonstrated the inexplicable wisdom of allowing only four women to be members at any one time.

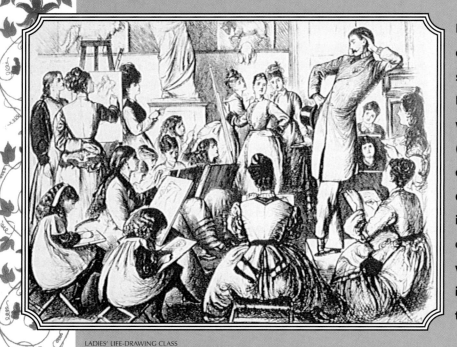

LADIES' LIFE-DRAWING CLASS

Education and aesthetics were also dictated by academies. They chose the professors at Paris's prestigious (and male-only) École des Beaux-Arts. When classicism was worshiped anew in the 18th century (see Winckelmann in chapter 1), hierarchies of subject matter were created that declared history and mythology more important than portrait, genre, landscape, or flower painting. Separate memberships were created for each category, pigeonholing artists. Women were excluded from the top category, history painting.

In 1790, after the French Revolution, Adelaide Labille-Guiard, painter and academy member, argued for more female members. She was unsuccessful, but managed to establish a free art school for girls. (It was eventually run by Rosa Bonheur.) Although it was difficult for women to become Academy members, they were accepted into the yearly Salons (exhibitions run by the Academy). Twenty-two percent of the artists in the 1835 Salon in France were women, a percentage that beats the number of women artists included in recent group exhibitions at The Museum of Modern Art or the Guggenheim Museum in New York. Women students were finally admitted to the school of the English Royal Academy in 1861 (they were not permitted to draw from live models until 1893) and the French École des Beaux-Arts in 1896. Of course, by that time, the academies had lost their influence.

RACHEL RUYSCH: SAYING IT WITH FLOWERS

Rachel Ruysch (1664-1750) was born in Amsterdam. Her father was a professor of botany and anatomy who had a big collection of rocks and skeletons that Maria Merian studied from. When Rachel was 15, she was apprenticed to a flower painter, Willem van Aelst. Later she married a portrait painter, Juriaen Pool, and moved to the Hague. Together they had ten kids and were members of the Painters' Guild. All her life, Rachel was swamped with commissions for her exquisite flower paintings. Flowers, especially tulips, were very important in Holland and were one of its major businesses. To paint them was to symbolize the wealth of the country and was not considered a second-rate activity, as in other parts of Europe. She was paid more for her work than Rembrandt was for his. She painted until she was 80 and died at 86. We think she was the supermom of her age.

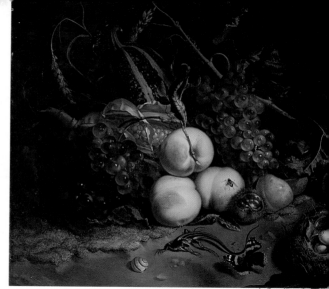

RACHEL RUYSCH, *FRUIT WITH INSECTS*, UFFIZI, FLORENCE, SCALA/ART RESOURCE, NEW YORK

ANGELICA KAUFFMANN: PLAYING HARDBALL WITH THE BIG BOYS

Not all the women artists of the 17th and 18th centuries painted domestic subjects. Angelica Kauffmann (1741-1807) took on the grand, historical themes. She was the daughter of a Swiss painter and talented at both painting and singing. While traveling through Italy with her father, she made copies of the Italian "masters." She also absorbed some of their heroic ambition. In 1766 she was brought to London by a wealthy Englishwoman to make her way as a painter. Within a year she had sold enough society portraits to buy a house and settle down. Her financial success freed her to do the history painting that she felt would put her in the major leagues. She had legendary charm and quickly became part of a social group that included the painters Benjamin West and Joshua Reynolds, German classicist Johannes Winckelmann (see chapter 1) and writer and biographer James Boswell. They espoused a kind of neoclassicism, calling for paintings that illustrated scenes from ancient history and mythology and employed a balanced restraint in the figures, reminiscent of Greek sculpture. Angelica became well known for painting in this style, despite the handicap of having learned to

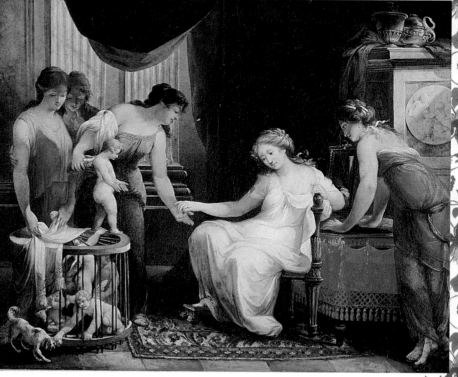

ANGELICA KAUFFMANN, *THE SELLERS OF LOVE*, MUSÉE BARGOIN, CLERMONT-FERRAND, SCALA/ART RESOURCE, NEW YORK

draw nude males from plaster casts instead of from life. She belonged to the English Royal Academy, and was accepted in a man's world.

But her personal life was scrutinized in ways that male artists' were not. Rumors swirled around her ill-fated engagement to a German count, who appeared to have been an impostor. Her close relationships with other male colleagues caused as much public comment as did her painting. The painter John Constable called her "decadent." Marriage to an Italian and a move to Italy stabilized her reputation. There she was accepted as a member of the Accademia di San Luca, whose members all marched in her funeral.

ÉLISABETH VIGÉE-LE BRUN: DANGEROUS LIAISONS

We asked Élisabeth Vigée-Le Brun (1755-1842), known in her lifetime as a prodigious correspondent, to write us a posthumous letter about herself:

Mes chères Guerrillas:

You have asked me to record my life as I lived it, including the last days of my beloved sovereign and patron, Marie-Antoinette. I was born in 1755 in Paris to Jeanne Massin, a beautiful woman and a loyal wife to my father, Louis Vigée, a great painter and the first admirer of my painterly instincts. From the age of 6 until 11, I lived in a convent, where I sketched constantly on every surface at hand: sand, walls, and in the margins of my exercise books. Often I was punished for this. But my father had great ambitions for my artistic talents. After my First Communion, I returned home and was surrounded by the many writers, artists, musicians, and actors whom Papa fêted with dinners and evening entertainments. When he died three years later, following a primitive operation to remove a fish bone he had swallowed, my family was thrown into a grief that I know not how we survived. Several of his old friends took it upon themselves to continue my painting instructions, and soon I was earning almost enough money with my portraits to support my family. Alas, it was not quite enough, so my mother married a wealthy jeweler, who took control of my earnings as well as my life. Soon thereafter I myself married, that rogue of an art dealer, Lebrun. Thinking I had escaped the drudgery of my stepfather's home, instead I entered more misery still, for my husband squandered my earnings on every sort of vice, including women of the least virtuous kind.

There were some consolations, though. Our home became one of the most lively salons in all of Paris, where, after a hard day at my easel, I organized gay evenings filled with music, plays, and costumes of the most inventive sort. By this time my paintings had attracted many aristocratic patrons. They preferred that I portray them as "ordinary people," without the wigs, corsets, jewelry, and other finery one saw in the work of my contemporaries. Among these esteemed persons was my sovereign, Marie-Antoinette, wife of Louis XVI, who came to such an ignoble end, losing the lovely head I so

admired to the blade of the guillotine. So many of my friends and colleagues from those days met terrible and unjust fates, some of them all the while believing in the revolution and supporting it with all their hearts.

Because I refused to renounce my royal friends, as many of my colleagues found it expedient to do, I was obliged to flee France at the beginning of the Reign of Terror. M. Lebrun, adventurer as he was, stayed behind to make his fortune with the new order. I was relieved that at last my life was to be my own. After an arduous journey, traveling in disguise with my seven-year-old daughter, we arrived in Italy. For the next 12 years Brunette and I followed exiled French nobility all over Europe as they and their wealthy friends were a constant source of work for me. I completed many portraits, visited all the art wonders of Europe, and was greeted with commissions, awards, and official entry into the Royal Academies of Rome, Parma, Bologna, St. Petersburg, Berlin, and Geneva. I was proud to already have been one of only four women permitted entry to the French Academy.

I remained loyal to Louis XVI, even after his death. I cannot attest to the same for my illustrious colleague and teacher, David. A frequent visitor to my Parisian salon, at a certain point, just before my flight, he stopped coming to my home because of my loyalties to the court. Then, during the Terror, he moved against many of his artist friends, resulting in their torture and imprisonment. Years later, when I was finally allowed to return to Paris, I was told that David wished to see me again. Even with the fear and danger over, and with nothing to lose by such an encounter, I could not bring myself to be in his company.

In sum, I did well. I supported myself and my family, and my work is in every royal collection in Europe. I was well known, and recognized wherever I went, and if it were not for my husband and the exigencies of history, I would have had great wealth. My life was arduous, but honorable. I would not change one single day.

Adieu mes amis,
Élisabeth

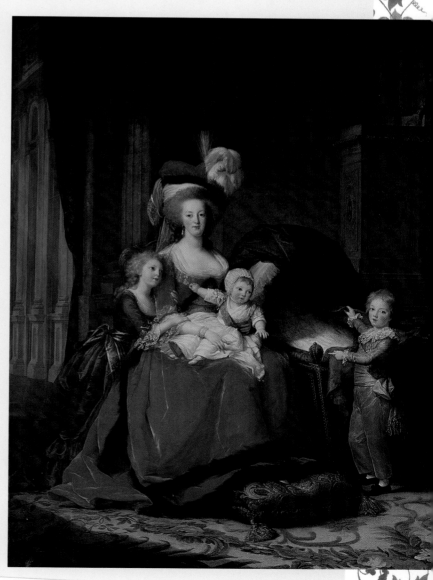

ÉLISABETH VIGÉE-LE BRUN,
MARIE-ANTOINETTE AND HER CHILDREN, 1787, CHÂTEAU
VERSAILLES/ART RESOURCE, NEW YORK

The 19th century saw the war to abolish slavery in the U.S. and the beginning of women's long struggle for equality. At the same time, male painters began to obsess over and objectify the naked female body as never before. Consider how many prostitutes and mistresses they painted, and how few suffragettes. Women who became artists–like Mary Cassatt, Rosa Bonheur and Edmonia Lewis–had to fight to be taken seriously. They were success stories, managing to live as they chose (often by traveling as far from home as they could). But the era abounds in horror stories, too, like Camille Claudel's.

There were great technological advances in the 19th century, including fast new ways–like the railroad and steamship–to leave home. The industrial revolution drew people from farms to factories and new tools made art production easier. At the same time, the invention of the camera threatened to make painting obsolete. Photography was great for women artists: because it was brand-new, there was no canon for them to be excluded from. As a result, women helped define the practice and continue to do so today.

ROSA BONHEUR: CROSS-DRESSING FOR SUCCESS

Rosa Bonheur (1822-1899) loved women and animals. She slept with the former and painted the latter. She was raised in a family of political idealists. Her mother died when she was eleven. Her father was an artist and a member of a utopian group that believed in gender equality. He was also the director of an art school for girls, where Rosa helped out and learned to paint.

Rosa's specialty was painting horses, cows, and bulls. Her first success came at age twenty-six, when she won a gold medal at the Salon of 1848. From this she received a commission from the French government for *Ploughing in the Nivernais,* which she based on the cow paintings of Paulus Potter (Dutch, 17th century) and descriptions of oxen in George Sand's 1846 novel, *La Mare au Diable.*

Rosa admired George Sand and, like her, often dressed in men's clothes, although

THE ONLY POSITION FOR WOMEN IN IMPRESSIONISM IS PRONE

In T.J. Clark's "groundbreaking" work on Impressionism, *The Painting of Modern Life: Paris in the Art of Manet and His Followers* (1984), no mention is made of Mary Cassatt, but 30 pages are devoted to prostitutes and courtesans.

she maintained that she did it "not for originality's sake, as too many women do, but simply to facilitate my work." To cross-dress in public she had to get a permit from the French police, signed by her doctor and renewable every six months (see left). It was invalid, however, for "balls and public spectacles." She and her life partner, Nathalie Micas, took vacations together in drag, as it afforded them a freedom denied to women traveling alone.

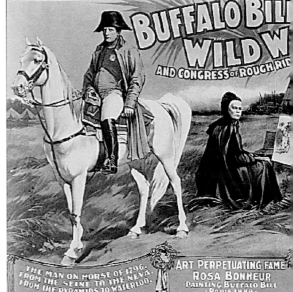

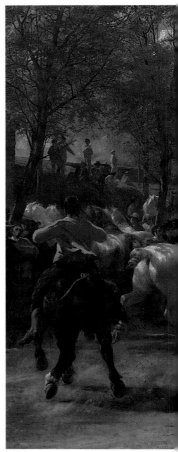

ROSA BONHEUR'S OFFICIAL CROSS-DRESS PERMIT

Rosa's *The Horse Fair,* 1853, made her one of the best-loved artists in Europe. "[Her] animals, although full of life and breed, have no pretensions to culture," wrote *The Daily News* critic in 1855. She was particularly revered in animal-loving England, where fans turned out to see her and newspapers chronicled her travels. The prominent painter Sir Edwin Landseer proposed marriage and even offered to become Sir Edwin Bonheur for her. Rosa, who considered herself married to Nathalie, was not excited by his proposal.

Rosa caught the eye of Buffalo Bill when he toured Europe with his Wild West Show. She did paintings of him along with Chief Red Shirt. She made a fortune selling her paintings and the rights to make engravings from them and was able to buy a large château at Fountainebleau, where her pet animals– lions, cows, camels, and wild mustangs–were allowed to roam free. She hunted, smoked cigars, and rode her horse astride through the streets of Paris. During the Franco-Prussian War, she trained with a rifle to defend her town from attack. She was the first woman to receive the award of Officier de la Légion d'Honneur. She made a life of her own, one far more unconventional than those of her contemporaries, the aesthetically-radical-but-socially-bourgeois Impressionists.

ROSA BONHEUR, *THE HORSE FAIR,* THE METROPOLITAN MUSEUM OF ART, NEW YORK, GIFT OF CORNELIUS VANDERBILT, 1887, PHOTO © THE METROPOLITAN MUSEUM OF ART

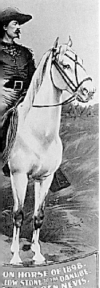

Unlike some 20th-century women artists who disavowed feminism after making it in a man's world, Rosa, like Mary Cassatt, was involved in the early women's movement. She was influenced by Flora Tristan, the grandmother of Gauguin, whose 1848 *The Emancipation of Women* demanded rights still sought by women today. She belonged to the Union of Woman Painters and Sculptors. Rosa encouraged women to be rebellious, saying, "Let women establish their claims by great and good works and not by conventions."

Rosa's reputation plummeted after her death, even though her painting *The Horse Fair* has been prominently displayed at The Metropolitan Museum of Art in New York for years. A work of hers that sold at Christie's for £4200 in 1888 went for only £46 in 1926.

Nathalie Micas, Rosa's lover until Micas's death, lived with her and took care of her, enabling Bonheur to focus on her painting. Late in life, Bonheur found a new love in the American painter Anna Klumpke. All three of them are buried side by side in the Père Lachaise cemetery in Paris.

Mlle Rosa almost paints like a man. What a pity her strong brush is not held by...the other precieux who paint like young ladies.
—THÉOPHILE THORÉ, ART CRITIC

ROSA BONHEUR AND HER LIFE PARTNER, NATHALIE MICAS

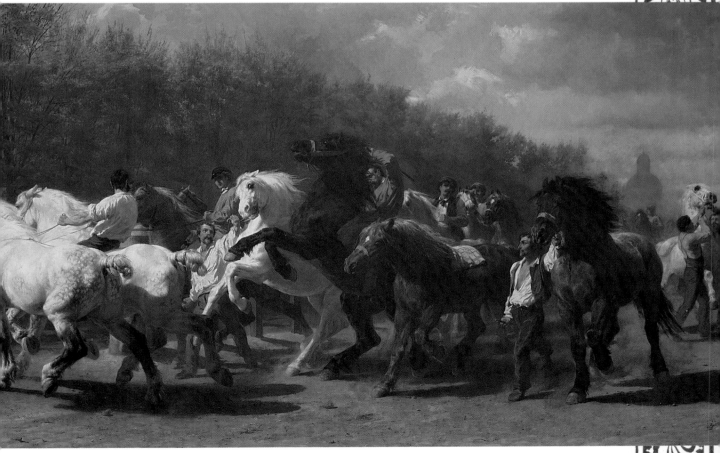

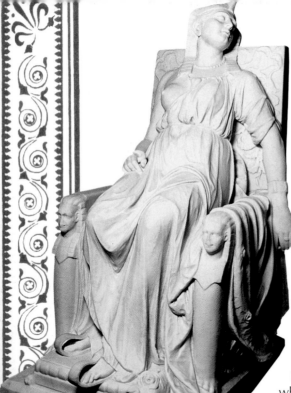

EDMONIA LEWIS: ROME VS. HOME

Edmonia Lewis had to go to Italy to make art about slavery in the U.S. She was African-American and Chippewa, born near Albany, New York, in 1845. She was orphaned at nine and sent to live with a Niagara Falls branch of the Chippewa tribe until her older brother, Sunrise, returned from the gold rush in California and sent her away to school, first to a Baptist college, then to Oberlin College in Ohio.

Oberlin in 1859 was an abolitionist hotbed, where, "If both are agreed, colored and white students walk together, eat together, attend classes together, and worship together." There Edmonia fell in love with drawing and was greatly affected by John Brown's raid on Harper's Ferry. (Brown's father was a founder of Oberlin, and two Oberlin African-Americans were part of the raiding party.)

In 1862, two of Edmonia's white roommates fell sick while on a sleigh ride with two guys. They accused her of poisoning them with wine spiked with an aphrodisiac. This shocked the puritanical town of Oberlin and enraged local racists. One night, Edmonia was carried off by a mob, beaten to a pulp, and left unconscious.

At her trial she was brilliantly defended by one of the first African-American lawyers, John Mercer Langston (who later became a congressman, founded the Howard University Law School, and was ambassador to Haiti). She was acquitted for lack of evidence, but she never recovered from the trauma. Suspicions about her continued, and she was accused of other, minor crimes, like stealing brushes from an art teacher. She was not allowed to register for classes for her final term and, at the age of eighteen, she left Oberlin for Boston, determined to redeem her reputation and become a sculptor.

ABOVE LEFT: EDMONIA LEWIS, *THE DEATH OF CLEOPATRA*, 1876, NATIONAL MUSEUM OF AMERICAN ART, SMITHSONIAN INSTITUTION, WASHINGTON, D.C., GIFT OF THE HISTORICAL SOCIETY OF FOREST PARK, ILL. RIGHT: EDMONIA LEWIS, *FOREVER FREE*, 1867, HOWARD UNIVERSITY ART GALLERY, WASHINGTON, D.C.

PLUS ÇA CHANGE, PLUS C'EST LA MÊME CHOSE.

At the Philadelphia Exposition in 1876, there was a big argument over whether women should show their work in a special Women's Pavilion or alongside men in the other pavilions. The Women's Pavilion presented furniture, crafts, textiles, appliances, and educational and scientific exhibits in addition to fine art. Some feminists thought the pavilion was a good idea; others, like Elizabeth Cady Stanton, were against it. Edmonia Lewis chose to show with the men, and her statue of Cleopatra drew crowds. Critics called the art in the Women's Pavillion inferior.

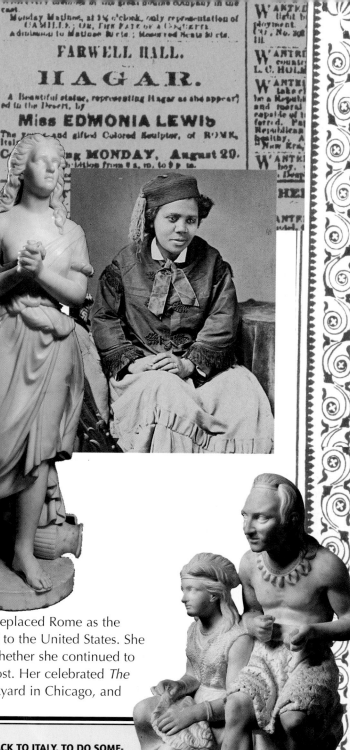

She became part of an intellectual circle in Boston and began to make sculptures of Abolitionist heroes. With money she made selling 100 plaster copies of a marble bust of a Civil War hero, she took off for Rome, where other American sculptors had established themselves.

In Rome, she learned to work in the then-fashionable neoclassical style. She was taken under the wing of a group of well-to-do American women artists, writers, and intellectuals–many of them lesbians. Among them were several marble sculptors, including Harriet Hosmer and Anne Whitney, who were very successful. They were the first all-female art movement–a girls' club.

Edmonia did all her own marble carving, partly to save money and partly to prove that a black woman could do it. She was treated as an exotic oddity, which she tried to use to her advantage. American tourists flocked to her studio to watch a black woman create art. She boldly sent sculptures, with invoices, back home to people who had not agreed to buy them. She returned to the United States several times, bringing tons of sculptures to sell (even taking her work as far as California), and was a big hit at the Centennial Exhibition in Philadelphia in 1876.

But right after that, neoclassicism went out of style, Paris replaced Rome as the place to be, and Edmonia's expatriate colleagues returned to the United States. She stayed behind and dropped out of sight. No one knows whether she continued to make art or when she died. Much of her work has been lost. Her celebrated *The Death of Cleopatra* was discovered in the 1970's in a junkyard in Chicago, and is now at the Smithsonian.

> "I AM GOING BACK TO ITALY, TO DO SOMETHING FOR THE RACE–SOMETHING THAT WILL EXCITE THE ADMIRATION OF THE OTHER RACES OF THE EARTH."
> –Edmonia Lewis

CLOCKWISE FROM TOP: NEWSPAPER AD ANNOUNCING EDMONIA LEWIS EXHIBITION; PHOTO FROM HER *CARTE DE VISITE*, SCHOMBURG CENTER FOR RESEARCH IN BLACK CULTURE, THE NEW YORK PUBLIC LIBRARY; *OLD ARROW MAKER*, 1866-72, NATIONAL MUSEUM OF AMERICAN ART, SMITHSONIAN INSTITUTION, WASHINGTON, D.C., GIFT OF JOSEPH S. SINCLAIR; *HAGAR*, 1875, NATIONAL MUSEUM OF AMERICAN ART, SMITHSONIAN INSTITUTION, WASHINGTON, D.C., GIFT OF DELTA SIGMA THETA SORORITY, INC.

If you were a 19th-century Girl...

・You could be used to symbolize democracy—e.g., The Statue of Liberty—but you weren't allowed to vote.

・You could not be the legal guardian of your own children or hold a job without your husband's permission.

・In France, your husband could divorce you if you gave him syphilis, but you couldn't divorce him if he gave it to you.

・You could finally become a practicing lawyer or doctor, but surviving law or med school was like surviving the Citadel today.

JULIA MARGARET CAMERON: THROUGH A LENS, SOFTLY

Julia (1815-1879) took her first photograph at the age of forty-eight.

She was born in Calcutta to a mother who was a French aristocrat and a father high up in the East India Company. He died when she was three, and the family returned to Europe to bury him; her mother died during the long sea voyage back. Julia was raised by her French grandmother and was later schooled in England. She returned to India at nineteen, and at twenty-three married Charles Hay Cameron, a champion of Indian law reform and civil rights, twenty years her senior. In India, and later when they returned to England, she did what wives of her class were expected to do: gave charming dinners, entertained writers and artists, did good works, had children (six in her case), and dabbled in poetry.

But Julia was lonely: Charles spent long periods in India, her children grew up, and the nest was empty. One of her daughters gave her a camera to help pass the time, and it immediately took over her life. She taught herself as she went along, turned her maids into darkroom assistants, and made portraits of everyone she could convince to pose, particularly beautiful young women and renowned old men. The women were picked to personify characters from poetry or myth (Echo, Psyche); the men were simply themselves (Alfred, Lord Tennyson, Charles Darwin).

PRE-RAPHAELITE STUDY, MAY PRINSEP

SUMMER DAYS

ALL PHOTOS BY JULIA MARGARET CAMERON, GERNSHEIM COLLECTION, HARRY RANSOM HUMANITIES CENTER, THE UNIVERSITY OF TEXAS AT AUSTIN

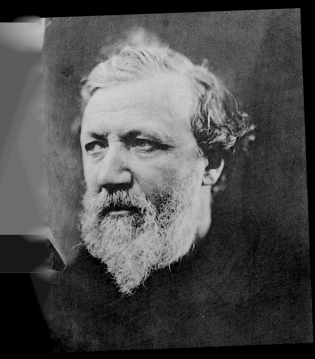

ROBERT BROWNING

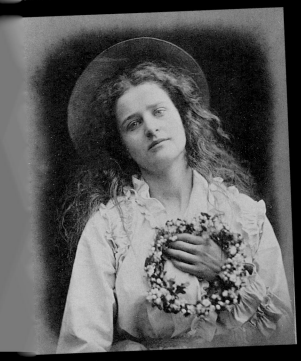

MAY QUEEN, MAY PRINSEP

Lewis Carroll (who also made photographs) saw Julia's early prints and said, "Hers are all taken purposely out of focus—some are very picturesque—some merely hideous—however, she talks of them as if they were triumphs of art." Like her contemporaries, Dante Gabriel Rossetti and the other Pre-Raphaelite painters, she had a passion for "beauty." As her work progressed, Julia produced books illustrating Tennyson's *Idylls of the King* and other poems, exhibited in juried shows and rented gallery spaces, received great reviews, and began an autobiography.

In 1875, Charles Cameron was made governor of Ceylon, and Julia agreed to drop everything and go with him. She made some photographs there, but took ill and died four years later.

From Ceylon, she wrote to a friend in England, "It is a sacred blessing which has attended my photography; it gives pleasure to millions and a deeper happiness to very many." She was in on the creation of a new kind of art.

HARRIET POWERS: SEW, SEW MODERN

In 1890, Harriet Powers and her husband, Armstead, freed slaves who farmed a couple of acres in rural Georgia, fell on hard times. A white art teacher, Jennie B. Smith, saw one of Harriet's story quilts at a local fair and offered her $5 for it. Harriet didn't want to part with the quilt but gave in when Jennie agreed to let her see it whenever she wanted. Jennie then entered the quilt in the Cotton States Exposition, where a group of women from Atlanta University saw it and commissioned Harriet to make another. Eventually the first quilt made its way to the Smithsonian; the second was given to Boston's Museum of Fine Arts. That is all we know about the needlework of Harriet Powers. We can only imagine what other quilts she might have made.

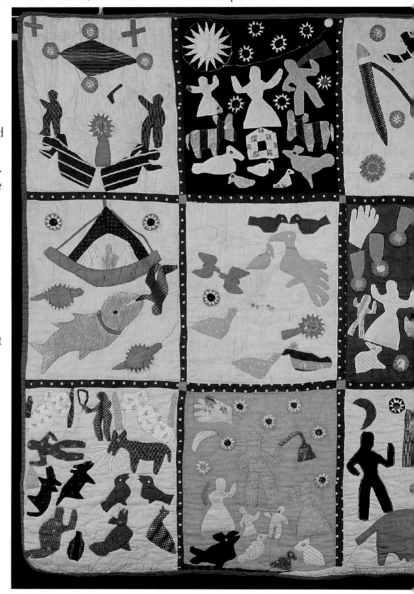

Harriet was born in slavery in 1837, married, had children, was freed, and lived until 1911. Like many slaves, who were forbidden to learn to read or write, she was illiterate. But she memorized the sermons and Bible stories she heard in church, along with folktales and accounts of current events, especially astronomical phenomena. She stitched these stories and events into the quilts that are her life's record. She gave long verbal accounts of each quilt's meaning.

Harriet probably learned traditional quilting in a plantation workshop where slave women (and sometimes men) produced all the clothing and fabric the estate needed. But the cutout, appliquéd figures are reminiscent of the textiles of West Africa, where Harriet's ancestors came from. Before Picasso and Matisse incorporated African motifs into their art, African-American quilters were doing the same thing. Why don't we know more about them? Guerrilla Girls demand that all curators of modern art take crash courses in the history of quilting, instead of arguing about who did what first in Paris circa 1912.

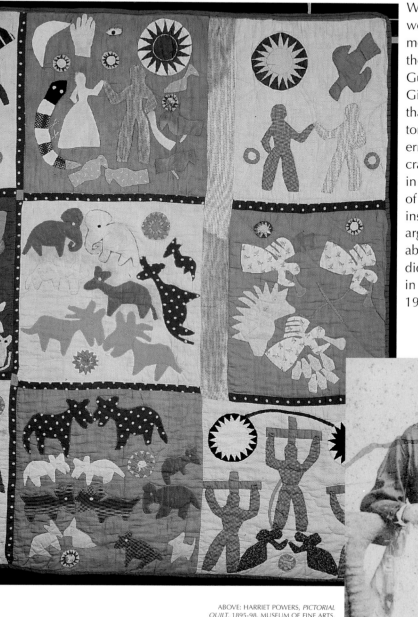

ABOVE: HARRIET POWERS, *PICTORIAL QUILT*, 1895-98, MUSEUM OF FINE ARTS, BOSTON, BEQUEST OF MAXIM KAROLIK

RIGHT: PHOTO OF HARRIET POWERS, MUSEUM OF FINE ARTS, BOSTON

MARY CASSATT: A BROAD ABROAD

Mary Cassatt, the American painter who worked with the French Impressionists, was never even given an obituary by *The New York Times* when she died in 1926. This infuriated us, so we decided to write one for her:

Guerrilla Times

PARIS, JULY, 1926- Mary Cassatt, the American painter who fled Philadelphia in 1866 to escape resistance to both women artists and new ideas about painting, died yesterday in Paris at the age of 81. While other expatriate American artists, like Whistler and Sargent, received elaborate coverage in *The New York Times*, the paper was silent on Cassatt's death, ignoring her contributions to art, and art collecting. Less than two decades earlier, a 1909 article in *Current Literature* magazine had proclaimed her "The Most Eminent of all Living Women Artists."

Cassatt was the only American artist whose work was respected and admired by the Almost-All-Male Club of Impressionists. This was a feat, considering the fact that she was never known to have posed nude or borne their illegitimate children.

While Cassatt's sex was not in her favor as a painter, her social class was. As the daughter of a wealthy industrialist, she had the financial means to leave Philadelphia and, in Paris, could afford private instruction. She never had to make a living from her work in order to do it. This separated her from less monied artist sisters, who had little choice but to take off their clothes to gain access to the "master" painters of the time.

Cassatt put her fortune to good use, especially in 1898, when she returned to the U.S. to promote her work and encourage wealthy friends to collect the new art from Europe. Undaunted by the rejection of her own painting because of prejudice, she was able to influence the formation of a major American collection, the Havemeyer Collection, housed at The Metropolitan Museum of Art, which initiated an era of modern art collecting in this country. Without her, there would not be large collections of Impressionism in American museums.

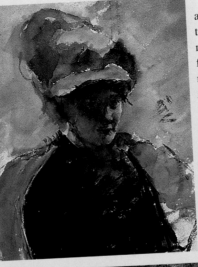

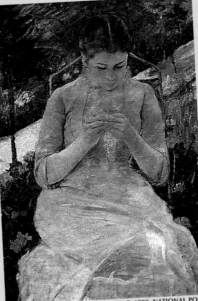

TOP: MARY CASSATT, *SELF-PORTRAIT*, C. 1880, NATIONAL PORTRAIT GALLERY, WASHINGTON, D.C./ART RESOURCE, NEW YORK; BOTTOM: *GIRL WORKING*, 1880-82, MUSÉE D'ORSAY, PARIS/ART RESOURCE, NEW YORK

While the political activism of male artists like Courbet and Pissarro were touted by art historians, it is rarely mentioned that Cassatt was an early feminist, involved in the Suffrage movement. She did a large mural, *Modern Woman*, for the 1893 Chicago Columbian Exposition and, along with Degas, participated in an exhibition in New York in 1915 to benefit women's rights. She also encouraged many women artists who sought careers in France.

Standard art history, following Victorian social values, dismissed Cassatt as a childless, frustrated spinster who compensated for her own maternal lack by painting portraits of women and children. In fact, Cassatt did not lack a family life, helping to raise a number of nieces and nephews who came to live with her in Paris in the 1870s. What's more, the domestic scenes for which she is best known constitute less than a third of her output. While her male colleagues were hailed for their depictions of the commonplace, a double standard was applied to Cassatt, whose similar subject matter was judged trivial.

A closer examination of Cassatt's work shows that she depicted women actively at work, at women's work, not as passive models or objects of the male gaze, as did many of the Impressionists. Her use of shifting perspectives and planar spatial representation, based on her interest in Japanese prints, was a radical revision in European painting. Her scenes of women in domestic situations, especially a 10-print series of 1891, influenced the young painter Matisse, who, all the same, continued to paint women as delectable objects.

CAMILLE CLAUDEL: CRAZY ABOUT RODIN

Camille Claudel (1856-1920) was the beautiful, talented assistant of the master sculptor Auguste Rodin, and went on to become his lover, muse, and intimate collaborator. Below is her life presented as a lurid movie poster.

SEX, LIES & SCULPTURE: THE LIFE OF CAMILLE CLAUDEL

She came to Paris in 1881 to study art. He was already a successful sculptor. She was 26, he was 40. They began an affair. Her parents kicked her out. He set her up in her own studio and brought her to work for him as an unpaid assistant and model.

During the decade they spent together, she helped him with some of his most important commissions and created most of her own best work. Their sculpture expressed an overt sexuality that became Auguste's claim to fame in the history of modernism. But that same eroticism in the work of a woman was shocking and indecent. Camille lost commissions because of it.

Over time, Camille became tormented by the fact that Auguste refused to be faithful to her or to openly acknowledge their relationship. She broke off with him. His reputation continued to grow, she became obscure and increasingly bitter and reclusive. When her father, who supported her, died, her brother had her committed against her will to an insane asylum. Her mother refused to ever speak to her again, and she remained institutionalized for thirty years, until her death. Rodin is remembered as a hero of art history, Claudel as a sorry victim in a stylish French film.

CAMILLE CLAUDEL, *VERTUMNE ET POMONE*, MUSÉE RODIN, PARIS

THE 20TH CENTURY:

WOMEN OF THE "ISMS"

WOMEN DON'T WANT TO BE
GRANTED EQUALITY; THEY
WANT TO WIN IT, WHICH IS
NOT THE SAME THING AT ALL.
–SIMONE DE BEAUVOIR

IN OUR CULTURE, WOMEN OF
ALL RACES AND CLASSES WHO
STEP OUT ON THE EDGE,
COURAGEOUSLY RESISTING
CONVENTIONAL NORMS FOR
FEMALE BEHAVIOR, ARE ALMOST
ALWAYS PORTRAYED AS CRAZY,
OUT OF CONTROL, MAD.
–BELL HOOKS

WHAT DO WOMEN WANT? THEY
WANT THE HUMAN TO BE NEI-
THER MAN NOR WOMAN.
–JEAN-FRANÇOIS LYOTARD

From the end of the 19th century to the first half of the 20th, revolution was on everyone's mind, including artists. Some wanted to change the world, others just wanted to change art. In Western art, movements and "isms" appeared, one after another: impressionism, postimpressionism, fauvism, cubism, futurism, constructivism, dada-ism, surrealism, expressionism, abstract expressionism, etc. Put them all together and what do we get? "Modernism."

Paris, Berlin, Moscow, and New York–each had its own stereotypical white male artist (see below). So where were the women? As usual, they didn't fit the stereotypes, but they were there, working away. Often they came up with innovations that their husbands got credit for. Sometimes they sublimated their careers so as not to outshine the men in their lives. Sometimes they could make art only when they retired from their day jobs. There was still lots of discrimination, still lots of critics nagging that women's work was not as good as men's. But there was also more opportunity than ever before for a woman to live her life and make art on her own terms. In the 20th century, women won rights never given to them before, including the right to vote. With more freedom, more women have become artists.

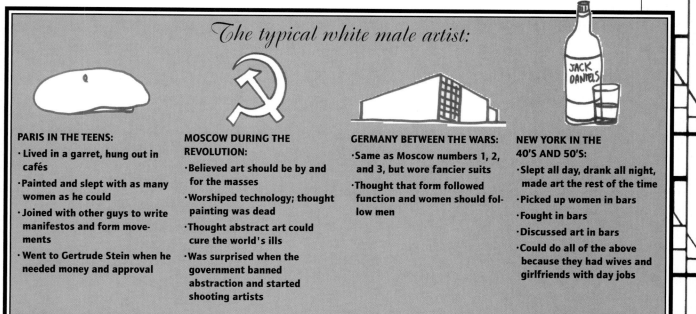

The typical white male artist:

PARIS IN THE TEENS:
· Lived in a garret, hung out in cafés
· Painted and slept with as many women as he could
· Joined with other guys to write manifestos and form movements
· Went to Gertrude Stein when he needed money and approval

MOSCOW DURING THE REVOLUTION:
· Believed art should be by and for the masses
· Worshiped technology; thought painting was dead
· Thought abstract art could cure the world's ills
· Was surprised when the government banned abstraction and started shooting artists

GERMANY BETWEEN THE WARS:
· Same as Moscow numbers 1, 2, and 3, but wore fancier suits
· Thought that form followed function and women should follow men

NEW YORK IN THE 40'S AND 50'S:
· Slept all day, drank all night, made art the rest of the time
· Picked up women in bars
· Fought in bars
· Discussed art in bars
· Could do all of the above because they had wives and girlfriends with day jobs

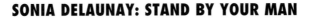

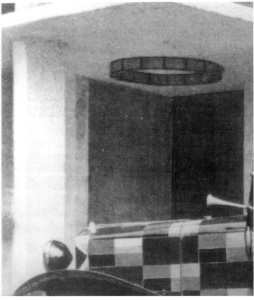

Sonia Terk Delaunay (1885-1974) had her first painting show in 1908 and didn't have another until 1953. Why? Because her husband, painter Robert Delaunay, entered–and hogged–the picture. Together they developed a theory of color they named simultanism, but he got most of the credit for it. Guerrilla Girls shake a hairy finger at any dense-headed critic or art historian who doesn't mention both of them in the same breath.

Sonia Terk was born poor in Russia but was adopted by a rich uncle who sent her to Paris to study art. To avoid going home, she entered into a marriage of convenience with her Parisian art dealer. Then she met Robert Delaunay, who was from an aristocratic family that had lost all its money but none of its airs. She got a divorce, married Robert, and they lived off her family income until she lost it during the Russian Revolution. While Robert kept his purity and the privilege to paint all day, Sonia supported him and their son, applied their ideas about color to design, and made "simultaneous" fabric, clothing, furniture, environments, and even cars. She transformed their home into a living testament to simultanism–with walls, floors, and ceiling covered with boldly painted surfaces. She opened a boutique, then went on to design rugs, tapestries, costumes, and sets for operas, ballets, and films. When Robert was in danger of being drafted during the First World War, they decamped to Spain and Portugal, where Sonia met and worked with Diaghilev and the Ballets Russes.

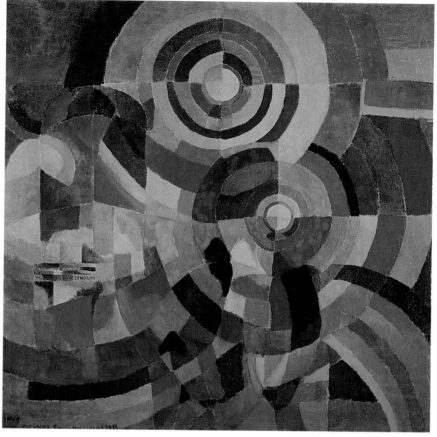

Sonia didn't mind that Robert was touted as the genius of the twosome. While his painting never changed very much over the years, Sonia was always innovating, thinking of new ways their ideas could be applied to the world at large. Her work pushed the envelope between art and life. Anyone who can read between the lines can see that without Sonia, Robert Delaunay might have been just another Parisian paint slinger. After his death, in 1941, she went on to paint again and have museum exhibitions of her own. She said, "I have led three lives: one for Robert, one for my son and grandsons, a shorter one for myself. I don't regret not having given myself more attention. I really did not have the time."

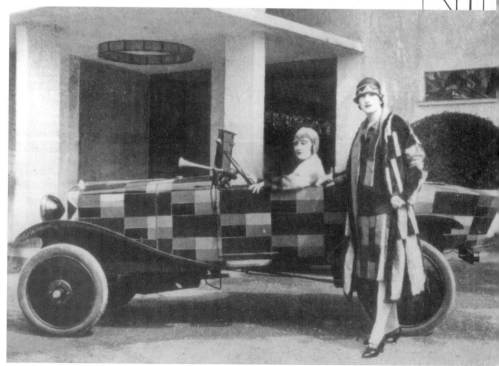

CLAUDE CAHUN: BOY AND GIRL TOGETHER

CLAUDE CAHUN,
SELF-PORTRAIT, 1928,
ZABRISKIE GALLERY

CLAUDE CAHUN,
SELF-PORTRAIT, 1929,
ZABRISKIE GALLERY

Claude Cahun was one of the first 20th-century females to dress up and photograph herself in the name of art. Claude, née Lucy Schwab, was born in Nantes in 1894. Her life partner and stepsister, Marcel Moore, née Suzanne Malherbe, collaborated with her on much of her work. Claude's sexual identity was so confounding that some books on surrealism list her as a man.

Claude took pictures of herself in a range of gender-bending stereotypes that would make Dennis Rodman jealous: male dandies, ultra-feminine maidens, and ambiguous andro-gynes. And she could be poetic about it. "Only artifice in me, so little primitive," she said. "Beneath this mask, another mask. I will never be finished lifting off all these faces," she wrote on a photograph.

Claude scandalized everyone, including the male surrealists she hung out with. Like her, they got off on flouting convention and shocking bourgeois society. Part of their shtick was to fetishize the feminine, presenting women in male-gener-ated stereotypes: muses, young virgins, vampires, decapitated and mutilated torsos. But, like so much Western art, their work was about men ogling women. Claude's pictures were a relief from this some-times monotonous aspect of art history. Instead of presenting herself as a passive object ready to be consumed by a heterosexual male gaze, she defiantly presents herself as both object and subject of her own sexual fascinations.

These surrealists, who marginalized the real women around them in favor of the idealized ones in their minds, were also homophobic. So Claude's statement about homosexuality (see above) was probably pretty surreal to them! Her assemblage of an eye, tufted with eye-lashes suggesting pubic hair, was a show-stopper in the legendary sur-realist exhibit of 1936. Writers on surrealism, mostly male, were able to appreciate Marcel Duchamp in drag as Rrose Selavy, but they wrote Claude out of their histories. She is only now being rediscovered.

Claude was a lesbian, a Jew, and a Marxist, three no-nos to the Nazis, who invaded France in 1940. Claude and Marcel fled to the Isle of Jersey, but eventually the occupiers marched north and took over the island. Our favorite couple had the guts to resist (see right). They were discovered in July of 1944, condemned to die, and imprisoned in soli-tary confinement until their execution. The Germans delayed, and Claude and Marcel were liberated ten months later. They never returned to Paris; Claude died in 1954.

NAZIS UNCOVER SECRET GUERRILLA GIRL CLUBHOUSE

Below is absolute proof that Claude and Marcel were the first Guerrilla Girls of the 20th century, from a German soldier's 1944 report about them.

"There are very few Jews in the islands. The two Jewish women who have just been arrested belong to an unpleasant category. These women had long been circu-lating leaflets urging German sol-diers to shoot their officers. At last they were tracked down. A search of the house, full of ugly cubist paintings, brought to light a quantity of pornographic mate-rials of an especially revolting nature. One woman had had her head shaved and been thus pho-tographed in the nude from every angle. Thereafter she had worn men's clothes. Further nude pho-tographs showed both women practicing sexual perversion, exhi-bitionism, and flagellation."

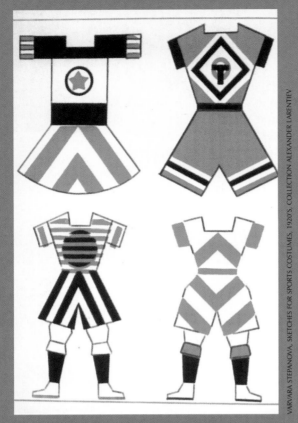

VARVARA STEPANOVA, SKETCHES FOR SPORTS COSTUMES, 1920'S. COLLECTION ALEXANDER LARENTIEV

For one short moment in the 20th century there was a time and place where women artists were as well respected as their male counterparts. This didn't happen in gay Paree or New York; it happened in Russia before and during the Revolution of 1917. Russian poet Benedikt Livshits called these women artists of the Russian Revolution "Amazons" from the East. Guerrilla Girls agree.

Females who wanted to be artists had a much easier time in Russia than in other parts of Europe. Women were admitted to the Saint Petersburg Drawing School starting in 1842, almost fifty years before art academies in France accepted women. When modernism and then the revolution hit, there were lots of girl artists ready to jump on the bandwagon.

In 1918, the year after the revolution, Lenin issued a decree urging artists to work for the revolution. Russian artists quickly declared easel painting decadent and created a new kind of abstract art meant to "uplift the masses." They designed posters, banners, textiles, clothing, books, and street theater. They outfitted trains with political slogans, pamphlets, and films and sent them traveling all over the countryside, promoting the revolution. They taught art to anyone who wanted to learn, in the Free Studios of Moscow.

But this story doesn't have a happy ending. Lenin died in 1924, and Stalin, who replaced him, had other ideas about art. Only certain kinds made him happy. So the party condemned abstraction as elitist and counter-revolutionary. Social realism–figurative, narrative art that romanticized and extolled the virtues of the communist regime–was mandated. Artists who didn't conform to the new dictum were purged from professional organizations. Some went into exile in the West; others were imprisoned. Many more worked the rest of their lives under government censorship. Women went back to their places. The dazzling experiment was over. Here is how some of our Amazon Commies got through these times.

ALEXANDRA EXTER traveled around Europe soaking up French cubism and Italian futurism. Back in Russia she became a cheerleader for modernism, getting to know artists all over and organizing shows of new art. During the revolution, she established an art school in Kiev and, with her students, designed agitprop (propaganda using art) trains. She also did theater sets and costumes and worked on early Russian films.

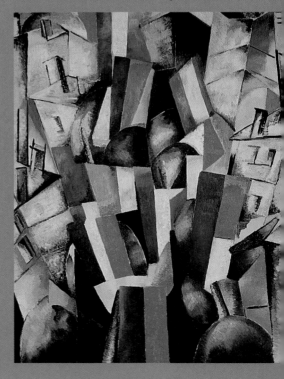

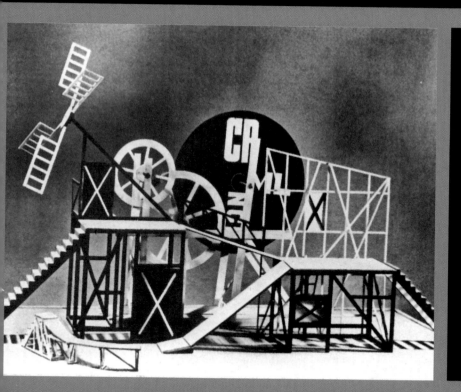

Disillusioned by the revolution, she took off for France in 1924, where she taught at Fernand Léger's Académie d'Art Moderne. She never attained the prominence in France that she had in Russia but continued to work until her death in 1949.

LIUBOV POPOVA gave up the comfort and wealth of her family, and then she gave up painting. All to work for the revolution. Born outside Moscow in 1889, she traveled all over Western Europe with her parents, who were art patrons. Back in Moscow she got to know other artists who were interested in modern ideas, and she started combining painting and sculpture in her work. Just after the revolution, she did her last easel painting, proudly stating, "Art is finished. It has no place in the working apparatus. Labor, technology, organization–that is today's ideology." She then got involved in stage design, children's theater, and puppetry, and collaborated with director Vsevolod Meyerhold on a production of Trotsky's *Earth in Turmoil*. In 1923, she was appointed head of the Design Studio at the First State Textile Print Factory. An epidemic swept through Moscow in 1924, taking Popova with it. She died at thirty-five, still believing in the revolution.

VARVARA STEPANOVA was born in Kovno, Russia, in 1894. In art school she met Alexander Rodchenko, who became her life partner and collaborator. In 1912, they moved to Moscow. She began to show her paintings, but also studied applied art and created a kind of concrete poetry, combining image and text. During the revolution, she, like Popova and Exter, became interested in the potential of design to create social change. She designed clothing for different occupations. She and Alexander remained in Russia after social realism became the order of the day. She focused mainly on graphic design and was for a while the art editor and designer for the magazine *Soviet Women*. Together they produced numerous books of documentary photographs about the U.S.S.R. Alexander died in 1956 and Varvara two years later.

VARVARA STEPANOVA,
COVER FOR *SOVIET CINEMA*,
NO. 1, 1927

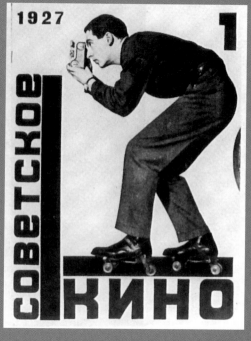

Hannah Hoch was a "good girl" among bad boys. That's what Hans Richter, the unofficial spokesperson for the Berlin dadaists, called her because she served sandwiches at their gatherings. Hannah was deeply offended by this label because she remembers not only serving the sandwiches but paying for them, too, being one of the few in the group who had a job. She did designs for embroidery and lace and won awards for them, but the guys thought her commercial work cheapened her real art.

Hannah met up with artist Raoul Hausmann while in school. They became involved with each other, and with dada, an art movement that challenged every convention (except male supremacy) and scandalized bourgeois society. Even though Hannah was one of the first artists to make photomontages, using images lifted from the media, the Dadas didn't want any Mamas and opposed her inclusion in their first international exhibition in 1921. Hannah protested by doing a skit at one of their soirées about a male artist who has a nervous breakdown when his wife asks him to do the dishes. They let her into the show.

Many of the collaged figures in her earliest photomontages were caricatures of "the new women," the German media's glorification of the independent, modern female, free to

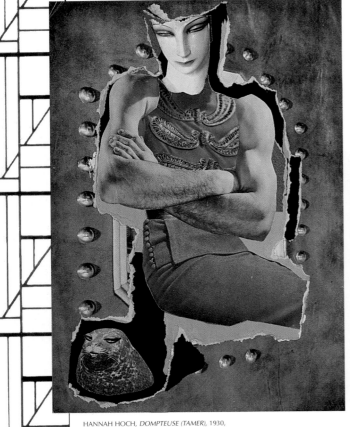

HANNAH HOCH, *DOMPTEUSE (TAMER)*, 1930,
KUNSTHAUS ZURICH, ©1998 ARTISTS RIGHTS SOCIETY (ARS),
NEW YORK/VG BILD-KUNST, BONN

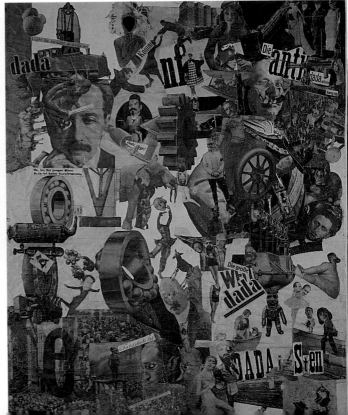

HANNAH HOCH, *THE KITCHEN KNIFE CUTS THROUGH
GERMANY'S FIRST WEIMAR BEER BELLY CULTURE*, 1919,
NATIONALGALERIE, STAATLICHE MUSEEN, BERLIN,
©1998 ARTISTS RIGHTS SOCIETY (ARS), NEW YORK/VG
BILD-KUNST, BONN, PHOTO © ERICH
LESSING/ ART RESOURCE, NEW YORK

the Mama Of DADa

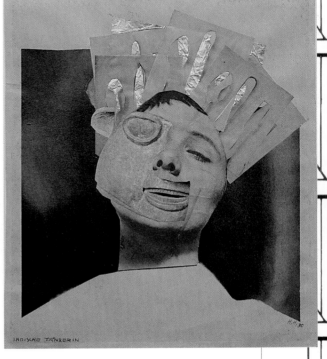

smoke, wear sexy clothes, vote, and work (and be the first to get laid off). One of her earliest montages contains a map of all the countries in Europe that had given women the vote (see the bottom of *The Kitchen Knife…*on page sixty-six).

Hannah eventually dumped Raoul, who insisted that her greatest contribution to art would be to support him while he was busy being a genius, and to give him a child. He also refused to leave his wife. She immediately started a nine-year lesbian relationship with Dutch poet Til Brugman. Her photomontages began to contain androgynous figures and same-sex couples. She also tweaked the Nazi party's obsession with racial purity by using non-Aryan figures, Africans and South Pacific islanders, in a series called the *Ethnographic Museum.*

When the Nazis took over, they came down hard on decadent modernists like Hannah. She and Til had ended their relationship, and Hannah married a man twenty years her junior. To avoid scrutiny, they moved to an obscure part of Berlin. They eventually broke up. Unlike most of her colleagues, who fled Germany, Hannah stayed and lay low, living out of her garden, hiding her collection of dada art, and not exhibiting any of her own work until after the war was over.

When the coast was clear, she began publishing in antifascist journals. She had a one-person show in 1949. Then, at sixty-five, she was given a government stipend as an artist.

Once dada was history, Hannah was included in retrospective shows about it, proving one of the Guerrilla Girls' Advantages of Being a Woman Artist: "Being included in revised versions of art history." But she was constantly arguing with the aging guys over what really happened during those years. From her statements below, the Dadas were really just the same Old Master Race with no Old Mistresses allowed.

LEFT: HANNAH AND TIL, C.1930; ABOVE: CARD ANNOUNC-ING HANNAH AND TIL'S RETURN TO BERLIN FROM HOLLAND, 1929, BERLINISCHE GALERIE, LANDESMUSEUM FÜR MODERNE KUNST, PHOTOGRAPHIE UND ARCHITEKTUR, ©1998 ARTISTS RIGHTS SOCIETY (ARS), NEW YORK/VG BILD-KUNST, BONN

HANNAH HOCH, *INDIAN DANCER: FROM AN ETHNOGRAPHIC MUSEUM,* 1930, THE MUSEUM OF MODERN ART, NEW YORK, FRANCES KEECH FUND, ©1998 ARTISTS RIGHTS SOCIETY (ARS), NEW YORK/VG BILD-KUNST, BONN, PHOTO ©1998 THE MUSEUM OF MODERN ART, NEW YORK

HANNAH HOCH ON HER MALE COLLEAGUES:

"They all desired this 'new woman' and her groundbreaking will to freedom. But they more or less brutally rejected the notion that they, too, had to adopt new attitudes."

"It was not very easy for a woman to impose herself as a modern artist in Germany….Most of our male colleagues continued for a long time to look upon us as charming and gifted amateurs, denying us implicitly any real professional status."

GUNTA STÖLTZL: WEAVERS VS. MASTERS AT THE BAUHAUS

> "Weaving? I thought it was too sissy. I was looking for a real job. I went into weaving unenthusiastically, as merely the least objectionable choice."
> —Anni Albers

In 1919 Walter Gropius, architect and teacher, found himself in big trouble. He wanted his new, experimental, state-run art school, the Bauhaus, to merge art and craft into one seamless practice. He wanted his school to be open to everyone. But when lots of ambitious, talented women applied, Gropius freaked out. None of the Bauhaus "masters" wanted women in their classes. So this master of the avant-garde sent women artists back to where they had been in ancient Greece and Rome—to the spinning wheel and loom. He declared the female sex "too strongly represented" at the Bauhaus and said they deserved their own Women's Department, which was short for weaving and textiles.

But sexist pigeonholing didn't discourage Gunta Stöltzl (1897-1983), one of those women who arrived at the Bauhaus in 1919, determined to become a modern artist. Within a year she had a full scholarship and went from being a student to supervising the entire weaving workshop, while the male "Master," who didn't weave, remained the titular head.

Other talented women, like Anni Albers, flooded the department, and together they made Bauhaus history, producing tapestries with the intricacy of paintings and industrial fabrics famous for their structural characteristics, like light reflection and sound absorption. They advanced the Bauhaus idea that form follows function.

Even though the products of the weaving workshop were best-sellers at all the Bauhaus fairs and sales, the department was always under attack from the "Masters," who disdained weaving as "woman's work." Female instructors were underpaid or, in the case of Anni Albers, unpaid. Gunta had to fight for raises and was denied a pension.

Under the Nazis, the Bauhaus itself came under attack, not, of course, for sexism, but for degenerate modernism. Many of the women in the workshop did not survive. Two top weavers and designers, Otti Berger and Friedl Dicker, both Jews, died at Auschwitz. Others whose affiliation with the Bauhaus tainted them lived in fear and seclusion in Germany for the duration of the war. Gunta had lost her German citizenship in 1929 when she married architect Arieh Sharon, a Palestinian Jew. They separated in 1931, and she was unable to get a passport until 1935.

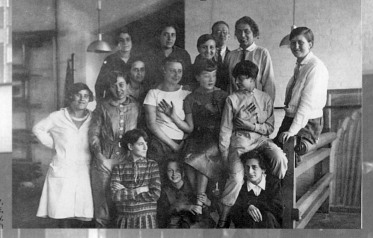

THE BAUHAUS WEAVERS, 1927, PHOTO: LOTTE BEESE, BAUHAUS-ARCHIV, BERLIN (GUNTA AT RIGHT)

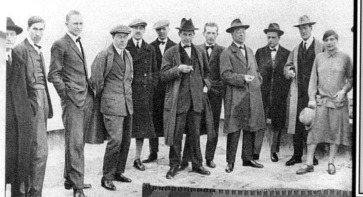

BAUHAUS

The next year, she emigrated to Switzerland with her young daughter, where she continued to weave. Gunta's work was collected by the Victoria and Albert Museum in London, the Busch Reisinger at Harvard, and The Museum of Modern Art in New York. She died in Zurich in 1983 at the age of eighty-six.

Any student can recognize the Bauhaus as the model for the curriculum that U.S. art schools have used for years. But women who have been to these schools recognize another practice that has been copied from the German masters— the small number of tenured female faculty members.

GUNTA STÖLTZL, TAPESTRY, 1926-27,
BAUHAUS-ARCHIV, BERLIN

> I thought
> I was
> revolutionary
> and I
> [realized]
> I was
> evolutionary.
> –Käthe
> Kollwitz

Berlin, 1944

Dearest Diary:

Sitting here listening to the bombers overhead, waiting to know if they will drop the calling cards of liberation on our heads, takes me back to other turbulent times I have seen here in Germany since I was born in 1867. My studio was destroyed last year in a raid. My husband died, my children and grandchildren are in peril. A rich American wants to smuggle me out of here to someplace safe, but I cannot go. My life's work is here. I am about this place.

My family was always involved in political struggles of one sort or another: battling the repression of the church, the corruption of Kaiser Wilhelm, the greed of industrialists who would sacrifice their workers for profits, those who would make war and kill children. Even now in my old age it continues: the Nazis called me decadent and took my husband's and son's medical practices from them. My life has been a constant battle. Look at my work to see this.

My father told me that since I was not pretty, I would never be hindered in my life by love affairs. So, what did I do? I got married as soon as I could, to Karl Kollwitz, a doctor who lived and worked among the poor. Karl never denied me my need to make art. In fact, I used his patients as models.

I gave up painting early in favor of graphic expression: prints, etchings, and lithographs. I wanted my work to have as many lives as copies could be made of them. It was not to earn more money: I printed many more cheap, unsigned copies than expensive, signed ones and gladly autographed them for anyone who asked. I have been told that refugees leaving Germany who are not allowed to take currency with them take my prints instead, to sell at their destinations. I am glad to be part of this subversion against a government that has threatened to send me, an old woman, to an extermination camp.

My whole life, I was never tempted to make images of things that I could not see or feel or touch. Those artists in Paris, Picasso and Matisse, have never interested me. I do not believe in art for art's sake! I even protested the exhibition of so-called modernism in German museums. But Rodin, there was an artist! I visited him in Paris in 1904. He inspired me to make sculpture–not small personal things, but large monuments. Later, I worked for years on a memorial to my son killed at the front in Belgium in the

Great War of 1916. It was about the human price of war, about the grief of two parents over a dead child. If you look, you will see that all my work has been about human suffering, not about the cruelty of the forces that oppress.

I never saw any limits for myself as a woman artist, but others did. I could not go to the regular art school but to a school for women artists instead. And look at what the Kaiser said when he refused me my medal in 1898 for my prints commemorating a workers' rebellion against his own uncle! I became the first woman professor at that school I could not get into, even though I was suspicious of such a status. (No worry now, the Führer has taken the post away from me.) I figured that if at least half of the world's suffering and injustice is committed against the female sex, who could tell their stories, the stories of mothers and children, stories of hunger and rape, better than I, a woman? Look at all those Madonnas in art history by men who don't know what it is like to suckle an infant!

I am also thinking of other political artists, whose work is better regarded by critics and historians than is mine. (I am better loved by those who are not artists, who know nothing of this modern abstraction that is everywhere.) Like George Grosz, who said I show an "invented, high-minded poor-people's ballet." I am not too old or too feeble-minded to see his argument against me as high-minded, too. I cannot stop fighting.

Käthe Kollwitz

OPPOSITE PAGE: KÄTHE KOLLWITZ, DETAIL OF *SELF-PORTRAIT*, 1934/ART RESOURCE, NEW YORK

RIGHT: KÄTHE KOLLWITZ, *UPRISING*, FOTO MARBURG/ART RESOURCE, NEW YORK

71

PAN YULIANG: FRENCH KISSING

Pan Yuliang, a Chinese painter who moved to Paris, had a life that was like a movie. In fact, the Chinese director Yimou Zhang (*Raise the Red Lantern*) made a film about her, starring Gong Li. Unlike Western films that usually present women artists as victims, failures, or lunatics, Zhang portrays Yuliang as a heroine who overcame the odds to live as she wanted.

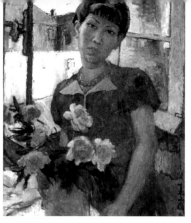

PAN YULIANG, *SELF-PORTRAIT*, C.1945, ANHUI MUSEUM, HEFEI

Yuliang was born in Yangzhou, Jaingsu, in 1899. She was orphaned at a young age and sold to a brothel. She met a patron, Pan Zhanhua, who took her as his legal concubine (he had another wife and family). An intellectual and political activist, he encouraged her interest in oil painting.

At that time in China, painters worked in traditional styles, using ink. Yuliang was more attracted to Western-style oil painting and its emphasis on individual expression, including the eroticism contained in the naked female figure. Many of Yuliang's early nudes were of herself, recorded in a looking glass. This fact, combined with her personal history, made her the subject of much social scorn. But at the same time she was respected for being a daring, Westernized artist.

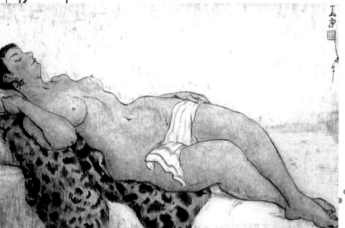

PAN YULIANG, *NUDE STUDY*, 1947, ANHUI MUSEUM, HEFEI

Yuliang found a mentor in Liu Haisu, one of the first Chinese artists who could paint in both Eastern and Western styles. He also introduced working from the nude in his school, the Shanghai Meizhuan. When Yuliang graduated in 1921, she won a scholarship and took off for Europe. She studied and worked for seven years in Lyons, Paris, and then Rome. She showed in all the right places and won awards.

In 1928 Yuliang went back to China, and Pan Zhanhua. She became a professor at the National Central University in Nanjing, where she taught until 1935. This was not a small feat for a woman with a background like Yuliang's. Still, her past haunted her, especially in the conservative university atmosphere. Disgraced because she was unable to bear Zhanhua a child, which she saw as her ultimate duty, and facing growing resistance to her free ideas about art, she returned to Paris, alone, in 1935. The revolution that was soon to come in China and the political chaos that followed would certainly have limited Yuliang's life and work. She lived the rest of her life in Paris, painting and making sculpture. She received the Gold Medal of the City of Paris in 1959. When she died in 1977, she bequeathed her unsold work to her hometown in China, where a museum is to be built in her memory.

TARSILA DO AMARAL: EAT MY MODERNISM

A recipe for Antropofagía, a modern concoction from Brazil by Tarsila do Amaral (1885-1973)

Ingredients:
- one childhood on a ranch in Capivari, Brazil, (near São Paulo)
- a wealthy family
- 1 trip to Paris with parents
- a couple more alone to France and Spain
- some sculpture and painting lessons à la française with Fernand Léger and Albert Gleizes
- shows in Paris, Moscow, and Brazil
- a romantic liaison with another Brazilian, poet Oswald de Andrade
- a surreal encounter with poet Blaise Cendrars in Paris
- a trip around Brazil in 1923 with Oswald and Blaise to see the mix of Old and New World cultures

Mix all the above together, pass through cubism. The result, a Brazilian art movement, Antropofagía, meaning "Cultural Cannibalism." The idea: when a New World artist devours all the diverse influences around her, she digests it all and expels something completely new. Mix with some political idealism via the Russian Revolution, add a trip to Moscow, and then a long life in Brazil, with a retrospective at the Museum of Modern Art in São Paulo in 1950 and The Museum of Contemporary Art in 1969. Viva Tarsila!

TARSILA DO AMARAL, *ANTHROPOPHAGY*, 1929, FUNDAÇÃO JOSÉ E PAULINA NEMIROVSKY, SÃO PAULO

GEORGIA O'KEEFFE: THE WOMAN WHO HATED FLOWERS

The following is from the Guerrilla Girls' scrapbook:

"The show is strong...one long, loud blast of sex, sex in youth, sex in adolescence, sex in maturity, sex as gaudy as *Ten Nights in a Whorehouse*, sex as pure as the vestal virgins, sex bulging, sex opening, sex tumescent, sex deflated....Perhaps only half the sex is on the walls, the rest is probably in me."
—Lewis Mumford reviewing Georgia O'Keeffe's work

When a guy shows his libido in his art, it's usually thought of as a noble gift to the world that is really about larger philosophical and aesthetic ideas. When a woman shows hers, she's a sex-obsessed nymphomaniac. Lewis Mumford's comments about Georgia (above) were more self-reflective than most. Marsden Hartley called Georgia's work "as living and shameless private documents as exist." Georgia, unflappable, saw the situation for what it was: "I wonder if man has ever been written down the way he has written women down," she wrote.

Georgia came out of nowhere, a woman with no wealth, no connections, born in Wisconsin in 1887, the daughter of an art teacher and a farmer. She was a no-nonsense, straightforward Midwesterner who did as she pleased and didn't fit anyone's mold. She had paintings and drawings that were unlike anyone else's. She also had photographer/art dealer Alfred Stieglitz, who brought her to New York, married her, promoted her work, and

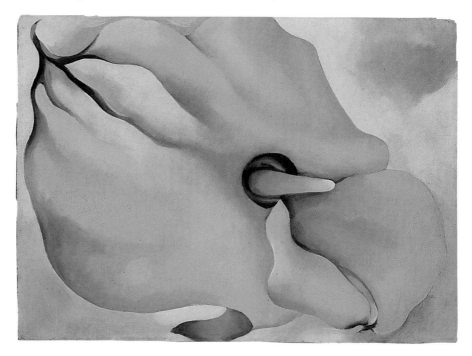

74

photographed her over and over again, creating a public image of her as an erotic icon. Was it his photos that forced such a prurient read of Georgia's work? Or was it the sexuality in her work that made him fall for her?

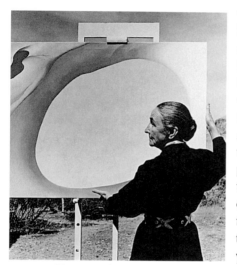

Georgia stayed in New York and became the most famous woman artist in the U.S. But after visiting New Mexico, she was hooked. She took off alone for summers there and, when Stieglitz died, moved there permanently, living in an adobe house in Abiquiu. People from all over the world came knocking on her door to pay homage. She was the first woman to have a retrospective at The Museum of Modern Art (there have been very few since). Late in life she even had the companionship of an attractive young assistant, something male artists of lesser talent enjoy as a matter of course.

Feminists love Georgia because she did unabashedly female work and because she made it in the art world with the big boys. Critics who pooh-pooh feminism, like Robert Hughes, belittle Georgia because feminists love her. What did Georgia herself have to say about the issue? When she arrived in New York in 1916, she joined

the National Women's Party. She was always outspoken about how she was treated and mistreated as a female, and in an interview in *The Masses,* a Marxist newspaper, she remarked that women were oppressed, but that in her heart of hearts, she'd rather talk about abstraction.

OPPOSITE PAGE: GEORGIA O'KEEFFE, *YELLOW CALLA*, 1926, NATIONAL MUSEUM OF AMERICAN ART, SMITH-SONIAN INSTITUTION, WASHINGTON, D.C., GIFT OF THE WOODWARD FOUNDA-TION, ©1998 THE GEORGIA O'KEEFFE FOUNDATION/ARTISTS RIGHTS SOCIETY (ARS), NEW YORK/ART RESOURCE, NEW YORK

ABOVE LEFT: GEORGIA O'KEEFFE IN NEW MEXICO C.1960, ARCHIVE PHOTOS

LEFT: GEORGIA O'KEEFFE AND ANDY WARHOL, 1983, PHOTO © CHRISTOPHER MAKOS

AUGUSTA SAVAGE: HARLEM ON HER MIND

Here is what we think a conversation with Augusta Savage, one of the most important African-American artists, might have been like:

GGs: *Augusta, tell us something about how you came to be an artist.*
Augusta: I was born in 1892, the seventh of fourteen children. My daddy was a preacher in Florida, and we lived near a brick factory where I just loved to play in the clay pits, making figurines of animals. To Daddy, it was the devil's work, and he almost "whipped all the art out of me" when he found out. But some teachers recognized my gifts and pretty soon I was teaching art in the same school I attended. By this time I was married and widowed, with my little baby to support, so I opened up a sculpture booth at the county fair and earned $175, quite a sum in those days. From this I got the idea that I should go to Harlem, where black folks were moving in droves, to be what I knew I was, an artist.

GGs: *What did you do once you got to Harlem? Wasn't there some scandal about your education?*
Augusta: I attended Cooper Union, which was free, and at the age of twenty-nine I was given a special stipend for living expenses. But my dream was to study in France. I heard about a summer program for women, so I applied, only to be rejected when white girls, much less qualified, were chosen. Was I ever mad! I complained to a very important man I knew, the head of the Ethical Culture Society. The selection committee said that if they accepted me, I would have to travel and eat separately from the others and that would make me uncomfortable, especially among my fellow students who were Southern. They said they rejected me for my own good! Can you imagine that? They were going to export American segregation to Europe, where nobody cared if black and white broke bread together. There were editorials and letters to the editors about it. A big, embarrassing scandal. But you know what? They never backed down and I didn't get to study in Europe until I was nearly forty. It made me strong but it set me back professionally, as I had already started late.

GGs: *What was it like to be an African-American woman artist in those days?*
Augusta: Among ourselves, we encouraged each other but beyond that, it was another story. Sure, there was a gallery that represented the estate of Henry Ossawa Tanner, but none would show the work of living black artists for fear that the artists and their friends would hang around the gallery and no white folks would come. Under pressure, some caved in and proposed special evening hours for "colored people." How insulting. You had to have a lot of courage as a black woman to set foot in the museums, too. At the State Fair in New Jersey, black artists were shown in the same section as the mentally impaired. The Museum of Modern Art always showed lots of African art because it made the modern white boys look good, but show African-American artists? It was out of the question. And the Works Progress Administration's art programs, meant to give work to the unemployed artists, set up special requirements that excluded black artists. I organized protests against the WPA that got us admitted, and then more protests because they wouldn't promote us to supervisors.

GGs: *Augusta, tell us about your own art.*

Augusta: Well, when I could find time to do it, I liked doing busts, portraits of people. I did black leaders like Marcus Garvey, W.E.B. Du Bois, and then people I knew: a wrestler, a little boy I saw on the street. But I never had enough money to cast my work in bronze. The commission I got for the World's Fair in 1937 was done in plaster for lack of funds, so it got destroyed. All that's left is a photo.

GGs: *You spent a lot of your life helping other black artists. Tell us about it.*

Augusta: I was the first African-American elected to the National Association of Women Painters and Sculptors, but I wanted a lot more than to be honored by the white world. I wanted to make it better for young artists, so I started a school, the Savage Studio of Arts and Crafts. Children came from all over and eventually it became the Harlem Community Arts Center, with me as director. It was the largest school of its kind in the whole United States. Almost every black artist you can think of came through my school. I was so proud of them! I also helped start the Harlem Arts Guild and the Vanguard Club, discussion groups where very important topics came up like the relationship between Africa and African-Americans, the role of politics in art, et cetera. Questions that are not answered to this day. I also remember having to lock horns with the Harmon Foundation, the white philanthropy that gave black artists money, and shows. Why, they didn't even have a black artist as a selector! We really had to start at the beginning. We had to fight just to get to square one.

GGs: *Augusta, what was your attitude toward African art? Didn't that get you into trouble too?*

Augusta: Well, I wasn't as interested in African art as many of my brothers and sisters were. You see, I wanted to integrate, not separate. I always told them, "For the last three hundred years we have had the same cultural background, the same system, the same standard of beauty as white Americans. In art schools we draw from Greek casts. It is impossible to go back to primitive art for our models." Yes, I paid a price for that. When they took the Arts Center away from me, I opened a gallery on 125th Street, the Salon of Contemporary Negro Art. It didn't work: there were people in Harlem to look at art but there was no one to buy art. Then, I decided to concentrate on promoting my own work, so I organized a nine-city tour of my sculpture. Midway, I ran out of money and had to cancel it. When they refused to let me go back to being the director of my school, that was the end of the Harlem Renaissance for me. I moved upstate, lived like an exile for seventeen years, doing whatever odd job I could find to get by. I even taught arts and crafts at a bungalow colony. My daughter brought me back to Harlem in the early sixties when I got too ill and old to take care of myself. That's my story.

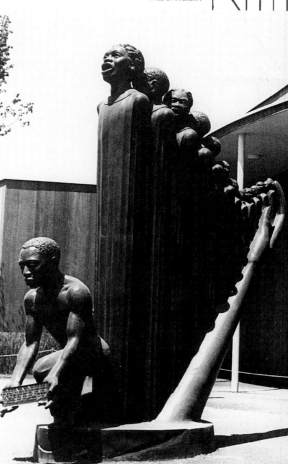

AUGUSTA SAVAGE,
LIFT EVERY VOICE AND SING, 1939,
PHOTO: CARL VAN VECHTEN, BEINECKE
RARE BOOK AND MANUSCRIPT LIBRARY,
YALE UNIVERSITY

GGs: *Augusta Savage died in 1962. Only nineteen of her sculptures have survived.*

Frida Kahlo:

AS SHE LAY DYING...

Yo soy Frida Kahlo. The Guerrilla Girls spoke for me when they demanded that art museums fund elaborate funerals for women artists that they plan to exhibit only after they are dead. My husband, Diego Rivera, was treated like a god in his lifetime (I treated him like a god, too), but I was a martyr and was canonized only after I had suffered and died. My first solo exhibition was just one year before I was dead. Some say it was given to me because I was about to go.

I was born in Coyoacán, Mexico City, in 1907. I was mestizo: my father a German Jew and my mother Spanish and indigenous. I didn't care for my European side. Instead, I played up my mother's heritage to the hilt: I wore peasant clothes, jewelry, and hairstyles. I even had false teeth encrusted with gold and gaudy jewels. I always had a hot temper and said what was on my mind. I called a *porquería* a *porquería*.

When I was eighteen I was in a horrible bus accident that I could describe in great disgusting detail if there was more room on this page. But it is enough to say that my pelvis was smashed, my spinal cord was mangled, and I was sewn back together but was crippled for life. I had thirty-two operations in twenty-nine years (and more miscarriages than I want to remember). In the end I lost my right leg to this and died young. Since I faced a life of suffering, I decided to make it my cross to bear. Instead of letting my infirmities keep me from fulfilling my ambitions, I used them as fuel for my art.

I seduced Diego when I was young and he was already a great painter. Our union was filled with tempestuous turns: we were married, divorced (it broke my heart), then married again. We hung out with a crowd of crazy bohemians: artists, writers, and left-wing politicos involved in philandering and political intrigues of every kind. Diego's womanizing tormented me, so I had some affairs of my own, with women, with men, it didn't matter. He was a macho; he carried a gun and would shoot it off whenever he felt like it. He rarely commented on our relationship in his grandiose, political murals, but for me the personal was political: I was constantly telling our story in my paintings.

My Marxist comrades declared easel painting "bourgeois individualism," but that was

FRIDA PAINTING IN BED, 1952

FRIDA BEING CARRIED INTO
HER 1953 EXHIBITION

78

their Eurocentric problem. I was a lifelong member of the Communist party—I even had its flag draped over the coffin at my funeral! But I never gave up making paintings, because mine were based on retablos: Mexican devotional paintings that depicted misfortunes and asked for miracles. I made them small, but with a punch to the belly equal to that of any gigantic mural you could imagine.

Diego's male painter friends didn't take me so seriously, but there was a group of white males who did: those surrealists. They believed their exploration of dreams and the unconscious mind was universal, crossing all times and cultures. They claimed me as one of them. "Thank you, misters, but I am in my own world, not yours," I told them.

FRIDA KAHLO,
SELF-PORTRAIT WITH MONKEY, 1940,
PRIVATE COLLECTION/ART
RESOURCE, NEW YORK

The world just loves women artists who are sad and dead. But I was the hero of my own life. This is what I did a few days before my show, the one just before I died: I had my bed, an elaborate one with a canopy, delivered to the gallery, covered with mirrors, skeletons, and pictures of my family and my political heroes. It reeked of my favorite perfume, Schiaparelli's "Shocking." Then, decked out in my best Mexican finery, I was transported to the show by ambulance with a police escort, carried by stretcher, and deposited on my grand bed. There I received the adulation of hundreds of my beloved friends and fans.

TINA IN THE MOVIE *A TIGER'S COAT*, 1920

Remember Marcel Duchamp, who claimed he was going to stop making art and play chess instead? Here's Tina Modotti (1896-1942), who really abandoned art–for a life of political activism and intrigue. Marcel's decision made him an art world hero. Tina's should make her a saint, because she gave up art to save the world.

Here are postcards that we imagine Tina might have sent us.

Mexico City, 1927

Dear Guerrilla Girls:

I came to San Francisco from Italy when I was sixteen and in four short years I managed to go from working in a sweatshop to starring in Hollywood movies. But I got tired of being stereotyped as a Latin femme fatale and hooked up with a bunch of left-wing L.A. bohemians, including photographer Edward Weston, and escaped to Mexico. I knew Edward slept with just about every woman he photographed, so I made a deal with him: I would be his mistress, model, and studio assistant only if he would teach me all he knew about taking pictures. Edward eventually went back to his wife in the States. I made my own career as a photographer. At first, I did still lifes. But then I became obsessed with the plight of the Mexican peasants. More soon. Love, Tina

Guerrilla Girls
532 LaGuardia Place, no. 237
New York, New York 10012

TINA MODOTTI,
BANDOLIER, CORN, GUITAR, 1927,
THROCKMORTON
FINE ART, NEW YORK

Moscow, 1938

Dear Guerrilla Girls:

Of course I joined the Communist party, way back in the twenties. The Mexican people needed so much, and Communism was their only hope in gaining power from the dictators. In 1929, my darling Julio Antonio Mella, a Cuban revolutionary, was assassinated at my feet. After that, I stopped taking pictures. I did what the Mexican people really needed, including running guns and many things I don't dare write about. But I didn't murder the president-elect, though I was accused of this and deported. Only Russia would take me in. My lover Vittorio Vidali and I worked for Stalin. I went undercover as a nun during the Spanish Civil War. Although comrades like Robert Capa, the war photographer, urged me to continue making photographs, I no longer wanted to. I now live for the people, not for art.

Yours, Tina

TINA MODOTTI,
WORKERS' PARADE, C. 1927,
THROCKMORTON FINE ART,
NEW YORK

Vittorio and Tina returned to Mexico in 1939 under false identities. She died suddenly in 1942 in the back seat of a taxi. Some say it was a heart attack, others say she was poisoned. After her death she was given a retrospective at the Galeria de Arte Moderno. We wonder if Tina, The Commie Who Abandoned Art, would feel violated by capitalism if she knew that in 1991 one of her photos was sold at auction for $165,000, the record price paid for a photograph at the time.

TINA MODOTTI, *CAMPESINOS*,
C.1927, THROCKMORTON FINE
ART, NEW YORK

MARIA MONTOYA MARTINEZ: THE WOMAN WHO STARTED A MOVEMENT

Art history has developed the habit of placing women artists outside the so-called mainstream. But Maria Martinez is a unique exception. She managed to create her own movement, one that has spawned a whole industry based on what she discovered and accomplished in her lifetime.

Maria, whose Native American name was Poveka, was born in the Tewa pueblo of San Ildefonso in New Mexico sometime in the 1880's. She and all four of her sisters worked in the family's pottery studio. They hand-built pots from coils of clay wrapped around a base, smoothed with gourds, scraped thin with the tops of coffee or tea tins, then polished to a shine with stones, then painted and fired to induce different color effects. Maria married Julian Martinez in 1904 and they made pottery together.

From 1907 to 1909, Maria and Julian helped excavate two Native American sites not far from their home. Shards of black, polished pottery were found, and Maria and Julian were asked how their ancestors might have made this kind of pot, the process having been forgotten. They worked for years, digging clay from secret pits in the mountains and mixing it with volcanic ash, then polishing and firing it to achieve a luminous, black color with matte black painted decorations.

MARIA MARTINEZ, BOWL, NATIONAL MUSEUM OF AMERICAN ART, SMITHSONIAN INSTITUTION, WASHINGTON, D.C., GIFT OF THE IBM CORPORATION/ART RESOURCE, NEW YORK

Maria's pots became so popular that she made hundreds of them, as well as non-traditional objects: boxes, candleholders, trays, and the like. When Julian died in 1943, Maria continued producing them with her entire family. Maria did not guard the secret of the blackware process, and other potters in the San Ildefonso pueblo began making similar pots. Soon, Maria's blackware became the signature style of the pueblo, and Julian's design of the *avanyu*–a mythical serpent with a tongue of lightning, symbolizing the need for rain–evolved into an emblem of San Ildefonso pottery. Maria made pots at many World's Fairs from 1904 on, and she traveled all over the U.S., demonstrating her skills. In 1978, the Renwick Gallery of the Smithsonian organized a show of her family's work.

It is amazing that history considers the Martinez lineage as matriarchal, generated from the personality of Maria rather than from her husband, Julian. History was not so kind to Sonia Delaunay or Lee Krasner. Perhaps the reasons for this lie in Maria's non-European roots, or perhaps in the second-class status assigned to crafts, making it more acceptable to bestow genius on a woman.

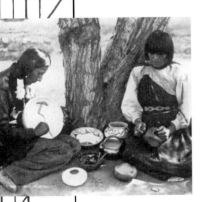

MARIA AND JULIAN, 1910, SANTA FE, NEW MEXICO, PHOTO ©1977 KODANSHA INTERNATIONAL LTD.

THELMA JOHNSON STREAT: DANCING ON A PAINTBRUSH

Thelma Johnson Streat (1912-1959) was the first African-American woman whose work was collected by The Museum of Modern Art in New York. She was also probably the first artist to dance in front of her painting at the museum.

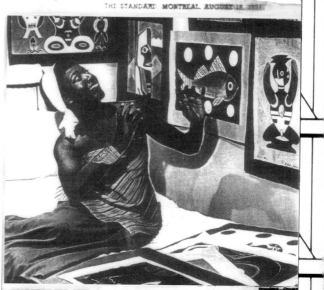

COMBINING THE ARTS. American primitive painter and folk dancer Thelma Johnson Streat, takes a characteristic pose before paintings on the wall of her room at the Laurentien Hotel. Miss Streat, who is currently vacationing in Canada, has paintings in the permanent collection of the Museum of Modern Art in New York.

THELMA ON TOUR, 1951

Thelma was born in Portland, Oregon. She studied painting at the Portland Art Museum and attended the University of Oregon. Then she traveled and lived all over the place: Canada, Chicago, San Francisco, Los Angeles, and Hawaii. She showed her work at many museums, including the De Young Museum, the San Francisco Museum of Art, the Newark Museum, and the Art Institute of Chicago. Diego Rivera admired her paintings, and they were bought by lots of Hollywood movie stars. She won prizes, made murals, gave lectures, and developed a style of dancing–with her paintings as backdrop–that was described in the early fifties as "interpretive" and "Afro-Primitive." She believed her dances to be the physical translation of the movement of her paintbrush. She choreographed movement based on African and Native American dances. Thelma was always interested in the history of African-Americans and their place in U.S. society; she was an early multiculturalist.

A beautiful woman, Thelma was noticed everywhere she went. She was called "a sensation." But the press couldn't get over the fact that she was black. The *Oregon Journal* in 1934 headlined an article on her "Colored Girl to Exhibit Paintings."

(She was twenty-two at the time.) Another announced, "Exhibition of Primitive Negroid Designs." When she got married in 1943, her hometown paper, *The Oregonian,* devoted a front-page story to it: "Negro Dancer of Portland Weds Caucasian Manager." Her husband worked for her, and together they traveled across the U.S., raising money for an art school for children of all backgrounds in Hawaii. She died suddenly of a heart attack in 1959, never realizing her dream of opening a school.

THELMA JOHNSON STREAT, *RABBIT MAN*, 1941, THE MUSEUM OF MODERN ART, NEW YORK, PURCHASE, PHOTO ©1998 THE MUSEUM OF MODERN ART, NEW YORK

ALMA THOMAS AND LEE KRASNER: BROAD STROKES

Alma Thomas (1891-1978) was an African-American painter in Washington, D.C., who was associated with the Washington color field painters. She started to paint full-time only after she retired from her job as a schoolteacher. Lee Krasner (1908-1984) was a Jewish-American painter in New York associated with the New York school–abstract expressionism. She was also the wife, then widow, of Jackson Pollock. We thought it would be interesting to imagine them having tea together…or maybe a double scotch:

Alma: Lee, what was it like to live your whole life in New York City and go to those prestigious art schools and hang out with all the other abstract expressionists? Me, I lived in Washington almost my whole life, after we moved north from Georgia. I did go to Teachers College at Columbia in New York, but I studied education. In my family, the men went to business (with success, I would add) and the women were teachers.

ALMA THOMAS, 1976, PHOTO: MIKE FISCHER, NATIONAL MUSEUM OF AMERICAN ART, SMITHSONIAN INSTITUTION, WASHINGTON, D.C./ART RESOURCE, NEW YORK

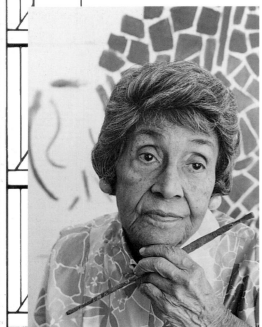

Lee: I went to the best art schools and I never felt discriminated against because I was female. Of course I had to work harder to be taken seriously, but that's the way of the world; you can't change that. I took it as a compliment when my teacher Hans Hofmann called a canvas of mine "so good you wouldn't know it was painted by a woman." I changed my name from Lenore to Lee, and signed my paintings with just my initials, but everyone was doing that, then. As for the abstract expressionists, the women who went to the Cedar Bar, where the guys got drunk and talked

ABOVE: ALMA THOMAS, *ELYSIAN FIELDS*, 1973, NATIONAL MUSEUM OF AMERICAN ART, SMITHSONIAN INSTITUTION, WASHINGTON, D.C., BEQUEST OF ALMA THOMAS/ART RESOURCE, NEW YORK

about art, were treated like cattle. You were lucky to have missed that.

Alma: Well, I did have the lifelong support of my colleagues and teachers, especially at Howard University, where I was the very first art student. Starting in the 1940's, I met regularly with other African-American artists, mostly schoolteachers like myself. We called ourselves "Little Paris," and we sketched and painted together and talked endlessly about art. We were more focused on European modernism than what was happening in New York. We were such outsiders that we even had

to start our own galleries. In 1943 I helped found the Barnett-Aden Gallery, which, I am proud to say, was the first integrated gallery in D.C.

Lee: New York was full of artists and galleries, but it wasn't easy to get your work shown, especially if you were female. We white women abstract expressionists didn't think we were being mistreated, although that's what the feminists would have us believe. Most of us were involved with the men who created the macho aesthetic. We loved them!

LEE KRASNER IN FRONT OF HER WORK,
©ARTISTS RIGHTS SOCIETY (ARS),
NEW YORK, PHOTO: CHWATSKY/ART
RESOURCE, NEW YORK

We were happy when they won acclaim. Jackson and I worked side by side for years, and our paintings evolved together. His were usually big. Mine were smaller. (His studio was in our big barn and mine was in a small upstairs bedroom.) I had my first one-person show at Betty Parsons when I was forty-three and I was so ashamed of my age that I shaved a couple of years off my bio. And I was careful not to show work that was similar to Jackson's since everyone assumed that our style was started by him.

Critics and historians want to believe that new ideas come from a single individual. They make art into a horse race. Even well-respected critics like Arthur Danto couldn't see me for who I was: "It is difficult to respond to her save as a shadow of artists greater than her, her teacher Hofmann, her husband, and her luminous contemporaries of the New York school." I couldn't avoid it, even after Jackson died. Being married to an art world "genius" didn't always work in my favor.

ABOVE: LEE KRASNER, *NOON*, 1947, ROBERT MILLER GALLERY, ©1998 POLLOCK-KRASNER FOUNDATION, ARTISTS RIGHTS SOCIETY (ARS), NEW YORK

LEE AND JACKSON AT HOME, 1950, SPRINGS, NEW YORK, LEE KRASNER PAPERS, ARCHIVES OF AMERICAN ART, SMITHSONIAN INSTITUTION, WASHINGTON, D.C., PHOTOS: WILFRED ZOGBAUM

Alma: You're right in that I never had to deal with any man complicating my life. I had it pretty much to myself. But you and I both came into our own late, after we had learned how to withstand all the injustices and cruelties. I was almost sixty and retired before I could become a full-time painter. I started to paint in bits and swatches of pure, bright color, based on things I could see in my own backyard. Then I took classes at American University and met those color field painters Kenneth Noland, Morris Louis, Sam Gilliam, and Gene Davis. I know that women are usually considered followers, but I was always mentioned as their artistic equal. Except, they had at least a twenty-five-year jump-start on me. They all had studios, too. But do you know where I did my paintings? On my kitchen table! You and I should start the Bedroom and Kitchen School of Art!

Lee: When Jackson died, stupid interviewers asked me things like "Do you feel

you have lost your identity because you happened to be the wife of Jackson Pollock?" Two of his girlfriends–one who was with him in the car when he crashed, and Peggy Guggenheim, who owned the famous fireplace he peed into–both sued the estate. When art critic Harold Rosenberg, who never had a kind thing to say about me, dubbed me the "Action Widow," to reinforce his theory of Jackson as an action painter, I decided to become a "Widow of Action." I renovated his studio for myself and got to work making big canvases. And collages from my old drawings.

For twenty years I painted and painted and finally in the seventies the art world was ready to acknowledge that an important woman artist could have been married to an important male artist. I've heard the rumor that pressure from feminist artists and art historians led to my retrospective at The Museum of Modern Art in 1983, but I don't believe it. Why would feminists help me, someone with absolutely no sympathy for their cause? I've done plenty for others, myself, though: I left my money (which mostly came from Jackson's posthumous sales) to The Pollock-Krasner Foundation to help needy artists.

Alma: Yes, it was a long haul for us both. I think I had three distinct lives: first as a teacher, then as a student, and finally as a painter. Fisk University organized a major show of my new work in 1971, when I was eighty. Then I had an exhibit at the Whitney Museum of American Art, in 1972, and an even larger one at the Corcoran Gallery of Art here in D.C. It was about time! Those Guerrilla Girls were right when they said that one of the advantages of being a woman artist is knowing your career might pick up after you're eighty. But that's a whole lot better than being a washed-up white male genius at thirty-five!

EVA HESSE: GIRL INTERRUPTED

Eva Hesse was one of the first girl artists to be taken as seriously as the boys. She died at only thirty-four, but in her last five years, she made an acclaimed body of work that changed the course of contemporary art. Eva was a Jewish war refugee, emigrating to New York from Germany (via Holland) with her parents in 1939. Her parents split up, her father remarried, and her mother committed suicide when Eva was ten. She was in psychoanalysis most of her adult life and kept a journal. Despite low grades in art, Eva always wanted to become a great painter. She went to Pratt Institute, then Cooper Union and Yale. At twenty-five, she married sculptor Tom Doyle but felt second-fiddle to him. She followed him to Germany for a year in 1964, despite the memory of her relatives who died in the camps. There she switched to making sculpture and read Simone de Beauvoir's *The Second Sex*.

Back in New York, Tom hooked up with another woman, and he and Eva split. She cut her long hair and began hitting her stride in her art. Using unconventional materials like latex, polyester resin, fiberglass, string, etc., she infused the vocabulary of minimalism with organic forms. While the other minimalists tried to drain their work of psychological associations, Eva's was filled with references, sexuality, even humor. Her sculptures overturned every rule: they leaned against the wall, connected corners, hung limp from the ceiling. She was immediately recognized as innovative and extraordinary, although a few macho critics panned her work for being soft–as though hardness is everything in art. Douglas Davis was particularly nasty, asking whether she was a "Cockroach" or a "Queen" in *Newsweek*. Guerrilla Girls bet he's eaten his words several times over by now.

Then, in 1968, Eva began vomiting and having severe headaches. It was a malignant brain tumor. She had operations, chemo, radiation, but nothing helped. All the while, she worked furiously with the help of

EVA HESSE, *REPETITION 19 III*, 1968, THE MUSEUM OF MODERN ART, NEW YORK, GIFT OF CHARLES AND ANITA BLATT. PHOTOGRAPH ©1998, THE MUSEUM OF MODERN ART

two assistants. In May 1970, she died. The Guggenheim Museum, not known for its generosity toward women artists, gave her a posthumous retrospective.

A few decades before, Georgia O'Keeffe was vilified for feminizing abstraction, but in the late 1960's, Eva Hesse was lauded for putting a girl's spin on miniMALEism.

ANA MENDIETA, *UNTITLED (FROM THE 'SILUETA' SERIES*, 1978, COURTESY THE ESTATE OF ANA MENDIETA AND GALERIE LELONG, NEW YORK

N.Y.G.G.P.D. REPORT

Name: Ana Mendieta

Date & place of birth: 1948, Havana, Cuba

Date & place of death: 1985, New York City

Family history: Born to wealthy Cuban family. Father supported Fidel Castro, then worked against him and was imprisoned. Ana and sister sent to U.S. as refugees, raised in orphanages and foster homes until mother and brother arrived in 1966. Lived in tiny apartment in Cedar Rapids, Iowa. Joined by father in 1979, after 20 years in prison.

Education: Studied art at University of Iowa, met many avant-garde New York artists, moved to New York after graduation.

Religion: Felt connection to Santeria, a Caribbean and Brazilian mixture of African and Catholic rites.

Profession: As a sculptor interested in ritual, staged events in which her actions and the objects she used became the art. Documented primarily by photographs. Examined her cultural background and deracinated position as Latina in Anglo culture.

Description of work: Conceptual and performance based. *Silueta* series in which she lay down, traced the outline of her body in earth, then lined it with sticks, stones, and flowers, then ignited it with gunpowder and firecrackers. Also known to have smeared herself with blood and feathers. Because work cut short by early death, who knows what she might have accomplished?

Miscellaneous information: First solo show in 1978 at AIR, gallery opened by women artists because gallery system excluded them.

Cause of death: Fall from high-rise apartment building

Marital status: Husband:Carl Andre, rich and famous white male minimalist sculptor

Whereabouts of husband at time of death: In apartment with her. Both alleged to have been intoxicated. Husband charged with murder but acquitted with help of well-paid attorneys.

TODAY WOMEN ARE EQUAL, RIGHT?

In our introduction, many pages back, you probably remember that we decided not to write about living women artists in this *Bedside Companion,* because we didn't want to put ourselves in the position of having to evaluate (or exclude) our peers. We think of ourselves as representing all women artists, not just a few. But this doesn't mean we can't discuss the collective accomplishments of our contemporaries, which have been enormous. How's it going for women artists today? Well...

It's been good...

• More women's art has been exhibited, reviewed, and collected than ever before. Dealers, critics, curators, and collectors are fighting their own prejudices and practicing affirmative action for women and artists of color. (The GG's take some of the credit for this.)

• Everyone except a few misogynist diehards believe there are–and have been–great women artists. Finally, women can benefit from role models and mentors of their own gender.

• Feminists have transformed the fields of art, history, and philosophy, making room for the point of view of the "other" (that's us, girls). They have made people aware that what most of us learned as objective reality was actually white male reality.

• Recently, there have been shows of openly gay and lesbian artists, and shows that attempt to explore homosexual sensibility.

• The age of the isms is over. Few art historians still cling to the idea that there is a mainstream, that art develops in a linear direction from artist A to artist B. In the current postmodern era, more kinds of art practice and more kinds of artists are accepted and written into the historical record. This is creating a truer, richer picture of the present and the past.

It's been bad...

• Women artists still get collected less and shown less. The price of their work is almost never as high as that of white males. Women art teachers rarely get tenure and their salaries are often lower than those of their male counterparts.

• Museums still don't buy enough art by women, even though it's a bargain! Our 1989 poster "When racism and sexism are no longer fashionable..." pointed out that for the amount of money spent at auction on a single painting by Jasper Johns, an art collector could have bought a work of art by every woman in this book!

• There's still a materials hierarchy, with oil paint on canvas at the top. Other media–like sculpture, drawing, photography, installation, and performance–are not quite as prestigious. Ironically, this has made it easier for women to make it in these fields.

• Museums and galleries in Europe and New York are the worst. All our research shows that the farther you get from New York and Western Europe, the better it gets for women and artists of color.

• Although the West has lost some of its cultural hegemony, the art of Asia, Africa and the Americas is still not accorded equal status with European art, or taught as often.

It's been ugly...

- Women of color are at the low end of the totem pole and have the hardest time getting their work shown. When they are exhibited, it's often as tokens: there never seems to be room for more than two or three in prestigious shows like the Whitney Biennial, Venice Biennial, etc.

- Some women still think that feminism is the "F" word.

- Women artists and theorists are still arguing over whether there is an essential female sensibility or whether the feminine is a cultural construct. GG advice: agree to disagree, find some common ground, and get on to more important things.

AND IT'S NOT OVER YET...

What would Western art history be without Gentileschi, Bonheur, Lewis, Kahlo, or any of the women who are or could have been in this book? What would contemporary art be without all the great women artists of the last few decades? Let's make sure that, generations from now, we never have to find out. Let's make sure that the work of women and artists of color is valued, exhibited, and preserved by our institutions. Guerrilla Girls plan to keep up the pressure on the art world. We'll continue to identify and ridicule the powers that be and to drag the misogynists and racists kicking and screaming into the 21st century. We invite you to join us. Tell your local galleries and museums how to behave. Write letters, make posters, make trouble.

FURTHER READING

GENERAL ART HISTORY

Dawn Ades, *Art in Latin America,* exhibition catalog, Hayward Gallery, London; and New Haven, Connecticut: Yale University Press, 1989

Romare Bearden and Harry Henderson, *A History of African-American Artists from 1792 to the Present,* New York: Pantheon Books, 1993

Norma Broude and Mary D. Garrard, editors, *Questioning the Litany,* New York: Harper & Row, 1982

Whitney Chadwick, *Women, Art and Society,* New York and London: Thames and Hudson, 1997

Elsa Honig Fine, *Women and Art: A History of Women Painters and Sculptors from the Renaissance to the 20th Century,* Montclair, New Jersey: Prior, 1978

Germaine Greer, *The Obstacle Race: The Fortunes of Women Painters and Their Work,* New York: Farrar Straus Giroux,1979

Ann Sutherland Harris and Linda Nochlin, *Women Artists: 1550-1950,* exhibition catalog, Los Angeles County Museum of Art, 1977

Samella Lewis, *African-American Art and Artists,* Berkeley and London: University of California Press, 1990

Alain Locke, *The Negro in Art: A Pictorial Record of the Negro Artist and of the Negro Theme in Art,* Chicago: Afro-American Press, 1969

Linda Nochlin, *Women, Art, and Power, and Other Essays,* New York: Icon, 1988

Roszika Parker and Griselda Pollock, *Old Mistresses: Women, Art and Ideology,* New York: Pantheon, 1981

Regina A. Perry, *Free Within Ourselves: African-American Artists in the Collection of the National Museum of American Art,* Introduction by Kinshasha Holman Conwill, National Museum of American Art, Smithsonian Institution, Washington, D.C.: Pomegranate Artbooks, 1992

Sherry Piland, *Women Artists: A Historical, Contemporary and Feminist Bibliography* (2nd ed.), Metuchen, New Jersey, and London: Scarecrow Press, 1994

Griselda Pollock, *Vision and Difference: Femininity, Feminism and the Histories of Art,* London and New York: Methuen, 1988

Charlotte Rubenstein, *American Women Artists: From Early Indian Times to the Present,* Boston: Avon, 1986

Wendy Slatkin, *Women Artists in History from Antiquity to the 20th Century,* Englewood Cliffs, New Jersey: Prentice Hall, 1990

Marilyn Stokstad, *Art History,* with collaboration of Marion Spears Grayson, with chapters by Stephen Addiss, Bradford R. Collins, Chu-tsing Li, Marylin M. Rhie, and Christopher D. Roy, New York: Abrams, 1995

WOMEN'S HISTORY

Georges Duby and Michelle Perrot, general editors, Natalie Zemon Davis, Annette Farge, Geneviève Fraisse, Christiane Kaplisch-Zuber, Pauline Schmitt Pantel, Françoise Thébaud, editors, *A History of Women in the West,* Volumes 1-5, Cambridge, Massachusetts, and London: Harvard University Press, 1993-94

Kate Greenspan, *The Timetables of Women's History: A Chronology of the Most Important People and Events in Women's History,* New York and London: Simon & Schuster, 1994

CLASSICAL GREECE AND ROME

Elaine Fantham, Helene Peet Foley, Natalie Boymel Kampen, Sarah B. Pomeroy, and Alan Shapiro, *Women in the Classical World: Image and Text,* New York: Oxford University Press, 1993

Sarah Pomeroy, *Goddesses, Whores, Wives, and Slaves: Women in Classical Antiquity,* New York: Schocken, 1995

Alex Potts, *Flesh and the Ideal: Winckelmann and the Origins of Art History,* New Haven, Connecticut, and London: Yale University Press, 1994

MIDDLE AGES

John Boswell, *Christianity, Social Tolerance and Homosexuality: Gay People in Western Europe from the Beginning of the Christian Era to the 14th Century,* Chicago: University of Chicago Press, 1989

Caroline Walker Bynum, *Jesus as Mother: Studies in the Spirituality of the High Middle Ages,* Los Angeles and London: University of California Press, 1984

Sabina Flanagan, *Hildegard of Bingen: A Visionary Life,* London and New York: Routledge, 1989

Carolyne Larrington, *Women and Writing in Medieval Europe: A Sourcebook,* London and New York: Routledge, 1995

Dorothy Miner, *Anastaise and Her Sisters: Women Artists of the Middle Ages,* exhibition catalog, Baltimore Museum of Art,1974

Christine de Pizan, *The City of Ladies,* translated by Earl Jeffrey Richards, New York: Persea Books, 1982

Christine de Pizan, *Ditié de Jehanne d'Arc,* edited by Angus Kennedy and Kenneth Varity, Oxford, England: Society for the Study of Medieval Languages and Literature, 1977

Charity Cannon Willard, *Christine de Pizan: Her Life and Works,* New York: Persea Books, 1984

RENAISSANCE TO 19TH CENTURY

Dore Ashton, *Rosa Bonheur: A Life and a Legend,* text by Dore Ashton, photos and captions by Denise Brown Hare, New York: Viking Press, 1981

Mary D. Garrard, *Artemisia Gentileschi,* Princeton, New Jersey: Princeton University Press, 1989

Helmet Gernsheim, *Julia Margaret Cameron: Her Life and Photographic Work,* New York: Aperture, 1987

Griselda Pollock, *Mary Cassatt,* New York: Hacker Art Books, 1987

Laura Ragg, *The Women Artists of Bologna,* London, 1907

Vigée-Le Brun, Élisabeth, *The Memoirs of Élisabeth Vigée-Le Brun,* translated by Sian Evans, Bloomington and Indianapolis: Indiana University Press, 1989

20TH CENTURY, GENERAL ART HISTORY

Avis Berman, *Rebels on 8th Street: Juliana Force and the Whitney Museum of American Art,* New York: Atheneum, 1990

Whitney Chadwick, *Women Artists and the Surrealist Movement,* New York and London: Thames and Hudson, 1991

Ann Gibson, *Abstract Expressionism: Other Politics,* New Haven, Connecticut: Yale University Press, 1997

The Great Utopia: The Russian and Soviet Avant-Garde, 1915-1932, exhibition catalog, Solomon R. Guggenheim Museum, New York; and New York: Rizzoli, 1992

bell hooks, *Art on My Mind: Visual Politics,* New York: Norton, 1995

Lucy Lippard, *Mixed Blessings: New Art in a Multicultural America,* New York: Pantheon, 1990

Jane Livingston and John Beardsley, *Black Folk Art in America, 1930-1980,* exhibition catalog, Corcoran Gallery of Art, Washington, D.C.; and University of Mississippi, Jackson, 1982

Richard J. Powell, *Black Art and Culture in the 20th Century,* New York and London: Thames and Hudson, 1997

Cecilia Puerto, *Latin American Women Artists: Frida Kahlo and Look Who Else,* a bibliography, Westport, Connecticut, and London: Greenwood Press, 1996

The Search for Freedom: African-American Abstract Painting, 1945-75, New York: Kenkeleba House, 1991

Significant Others: Creativity and Intimate Partnership, edited by Whitney Chadwick and Isabelle de Courtivon, New York and London: Thames and Hudson, 1993

Michael Sullivan, *Art and Artists of Twentieth-Century China,* Los Angeles and London: University of California Press, 1996

Sigrid Wortmann Weltge, *Women's Work: Textile Art from the Bauhaus,* San Francisco: Chronicle Books,1993

M. N. Yablonskaya, *Women Artists of Russia's New Age, 1900-1935,* New York and London: Rizzoli,1990

20TH CENTURY, INDIVIDUAL ARTISTS

Barbara Bloemink, *Georgia O'Keeffe: Canyon Suite,* New York: Braziller, 1995

Gladys-Marie Fry, *Stitched from the Soul: Slave Quilts from the Ante-bellum South,* Museum of American Folk Art, New York; and New York: Dutton, 1990

Hayden Herrera, *Frida: A Biography of Frida Kahlo,* New York: HarperPerennial, 1991

Margaret Hooks, *Tina Modotti: Photographer and Revolutionary,* London and New York: Pandora, 1993

Käthe Kollwitz, exhibition catalog, with essays by Elizabeth Prelinger, Alessandra Comini, and Hildegard Bachert, National Gallery of Art, Washington, D. C.; and New Haven, Connecticut, and London: Yale University Press, 1992

Therese Lichtenstein, "A Mutable Mirror: Claude Cahun," *Artforum,* April 1992

Lucy Lippard, *Eva Hesse,* New York: New York University Press, 1976

Robert Katz, *Naked by the Window: The Fatal Marriage of Carl Andre and Ana Mendieta,* New York: Atlantic Monthly Press, 1990

Susan Peterson, *Maria Martinez: Five Generations of Potters,* exhibition catalog, Renwick Gallery of the National Collection of Fine Art, Washington, D.C.: Smithsonian Institution Press, 1978

The Photomontages of Hannah Höch, exhibition catalog, with essays by Peter Boswell and Maria Makela, Minneapolis: Walker Art Center, 1997

Anne Middleton Wagner, *Three Artists (Three Women): Modernism and the Art of Hesse, Krasner, and O'Keeffe,* Los Angeles and London: University of California Press, 1996

ACKNOWLEDGMENTS

This book is dedicated to all past, present, and future Guerrilla Girls (you know who you are!) and to the significant others, offspring, and friends who help us rumble in the jungle.

We send special smooches and bananas to our editor, Wendy Wolf; our agent Dan Mandel; and in memory of our agent Diane Cleaver.

We extend a hairy hand to (in alphabetical order): Avis Berman, Tina Brown, Carmen Bambach Cappel, Whitney Chadwick, Elena Ciletti, Kinshasha Conwill, T Cruse, Paul Evans, Susan Faludi, Tom Finkelpearl, Franklin Furnace, Ann Gibson, Jim Gorman, David Hawk, Hayden Herrera, Betsy Hesse, Barbara Hoffman, bell hooks, Alison Jasonides, Rebecca Katz, Annette Kuhn, Carrie Lederer, Maya Lin, Bob Lipsyte, Robin Morgan, Françoise Mouley, Tom Muller, Peter and Eileen Norton, Faith Ringhold, Richard Ross, Mira Schor, Ntozake Shange, Elizabeth Shepard, Peter Silverman, Teri Slotkin, Roberta Smith, Bob Stein, Gloria Steinem, Rob Storr, Allison Strickland, Frances Terpak, John Wands, and Jane Wheeler.

We thank the art historians who have shared their research and the moles in museums and galleries around the world who have risked their jobs to help us gather information.

We'd love to hear from you. Please write us at 532 LaGuardia Place, #237, New York, New York 10012 or (f)E-mail to guerrillagirls@voyagerco.com.

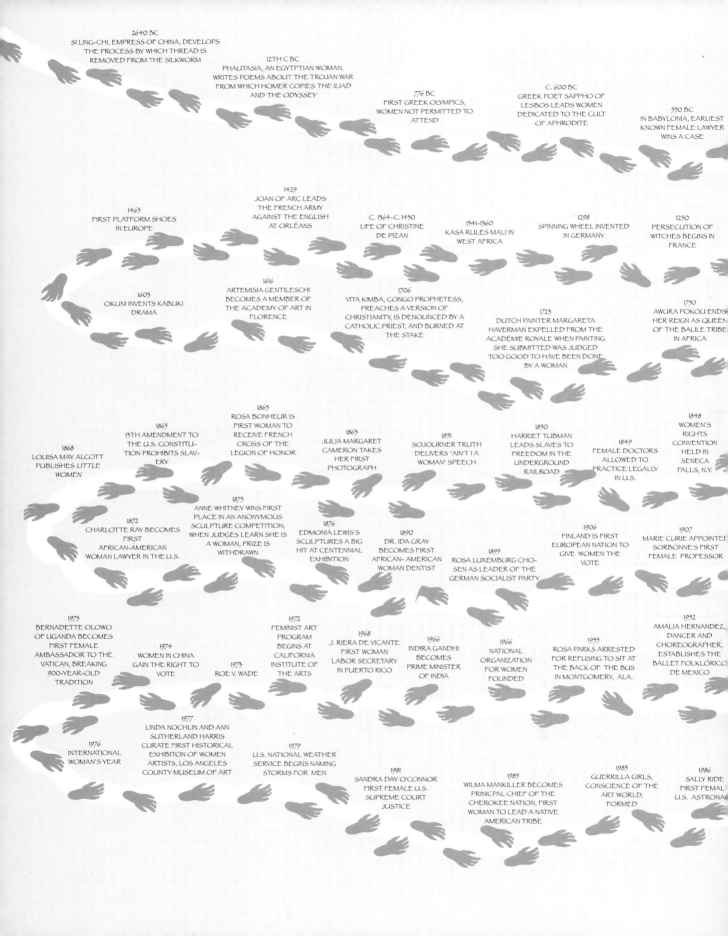

2640 BC
SI LING-CHI, EMPRESS OF CHINA, DEVELOPS THE PROCESS BY WHICH THREAD IS REMOVED FROM THE SILKWORM

12TH C BC
PHAUTASIA, AN EGYPTIAN WOMAN, WRITES POEMS ABOUT THE TROJAN WAR FROM WHICH HOMER COPIES *THE ILIAD* AND *THE ODYSSEY*

776 BC
FIRST GREEK OLYMPICS, WOMEN NOT PERMITTED TO ATTEND

C. 600 BC
GREEK POET SAPPHO OF LESBOS LEADS WOMEN DEDICATED TO THE CULT OF APHRODITE

550 BC
IN BABYLONIA, EARLIEST KNOWN FEMALE LAWYER WINS A CASE

1465
FIRST PLATFORM SHOES IN EUROPE

1429
JOAN OF ARC LEADS THE FRENCH ARMY AGAINST THE ENGLISH AT ORLÉANS

C. 1364-C. 1430
LIFE OF CHRISTINE DE PIZAN

1341-1360
KASA RULES MALI IN WEST AFRICA

1298
SPINNING WHEEL INVENTED IN GERMANY

1250
PERSECUTION OF WITCHES BEGINS IN FRANCE

1603
OKUNI INVENTS KABUKI DRAMA

1616
ARTEMISIA GENTILESCHI BECOMES A MEMBER OF THE ACADEMY OF ART IN FLORENCE

1706
VITA KIMBA, CONGO PROPHETESS, PREACHES A VERSION OF CHRISTIANITY, IS DENOUNCED BY A CATHOLIC PRIEST, AND BURNED AT THE STAKE

1723
DUTCH PAINTER MARGARETA HAVERMAN EXPELLED FROM THE ACADÉMIE ROYALE WHEN PAINTING SHE SUBMITTED WAS JUDGED TOO GOOD TO HAVE BEEN DONE BY A WOMAN

1750
AWURA POKOU ENDS HER REIGN AS QUEEN OF THE BAULE TRIBE IN AFRICA

1868
LOUISA MAY ALCOTT PUBLISHES *LITTLE WOMEN*

1865
13TH AMENDMENT TO THE U.S. CONSTITUTION PROHIBITS SLAVERY

1865
ROSA BONHEUR IS FIRST WOMAN TO RECEIVE FRENCH CROSS OF THE LEGION OF HONOR

1863
JULIA MARGARET CAMERON TAKES HER FIRST PHOTOGRAPH

1851
SOJOURNER TRUTH DELIVERS "AIN'T I A WOMAN" SPEECH

1850
HARRIET TUBMAN LEADS SLAVES TO FREEDOM IN THE UNDERGROUND RAILROAD

1849
FEMALE DOCTORS ALLOWED TO PRACTICE LEGALLY IN U.S.

1848
WOMEN'S RIGHTS CONVENTION HELD IN SENECA FALLS, N.Y.

1872
CHARLOTTE RAY BECOMES FIRST AFRICAN-AMERICAN WOMAN LAWYER IN THE U.S.

1875
ANNE WHITNEY WINS FIRST PLACE IN AN ANONYMOUS SCULPTURE COMPETITION; WHEN JUDGES LEARN SHE IS A WOMAN, PRIZE IS WITHDRAWN

1876
EDMONIA LEWIS'S SCULPTURES A BIG HIT AT CENTENNIAL EXHIBITION

1890
DR. IDA GRAY BECOMES FIRST AFRICAN-AMERICAN WOMAN DENTIST

1899
ROSA LUXEMBURG CHOSEN AS LEADER OF THE GERMAN SOCIALIST PARTY

1906
FINLAND IS FIRST EUROPEAN NATION TO GIVE WOMEN THE VOTE

1907
MARIE CURIE APPOINTED SORBONNE'S FIRST FEMALE PROFESSOR

1975
BERNADETTE OLOWO OF UGANDA BECOMES FIRST FEMALE AMBASSADOR TO THE VATICAN, BREAKING 900-YEAR-OLD TRADITION

1974
WOMEN IN CHINA GAIN THE RIGHT TO VOTE

1973
ROE V. WADE

1972
FEMINIST ART PROGRAM BEGINS AT CALIFORNIA INSTITUTE OF THE ARTS

1968
J. RIERA DE VICANTE FIRST WOMAN LABOR SECRETARY IN PUERTO RICO

1966
INDIRA GANDHI BECOMES PRIME MINISTER OF INDIA

1966
NATIONAL ORGANIZATION FOR WOMEN FOUNDED

1955
ROSA PARKS ARRESTED FOR REFUSING TO SIT AT THE BACK OF THE BUS IN MONTGOMERY, ALA.

1952
AMALIA HERNANDEZ, DANCER AND CHOREOGRAPHER, ESTABLISHES THE BALLET FOLKLÓRICO DE MEXICO

1976
INTERNATIONAL WOMAN'S YEAR

1977
LINDA NOCHLIN AND ANN SUTHERLAND HARRIS CURATE FIRST HISTORICAL EXHIBITON OF WOMEN ARTISTS, LOS ANGELES COUNTY MUSEUM OF ART

1979
U.S. NATIONAL WEATHER SERVICE BEGINS NAMING STORMS FOR MEN

1981
SANDRA DAY O'CONNOR FIRST FEMALE U.S. SUPREME COURT JUSTICE

1985
WILMA MANKILLER BECOMES PRINICPAL CHIEF OF THE CHEROKEE NATION, FIRST WOMAN TO LEAD A NATIVE AMERICAN TRIBE

1985
GUERRILLA GIRLS, CONSCIENCE OF THE ART WORLD, FORMED

1986
SALLY RIDE FIRST FEMALE U.S. ASTRONAUT